IMAGES
of England

LUTON

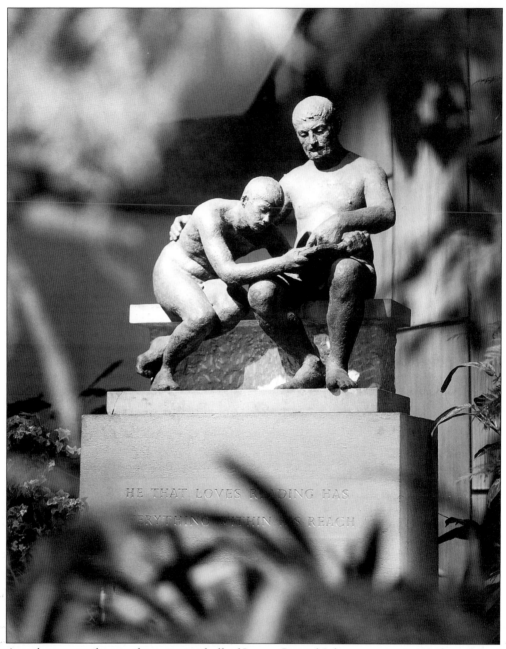

A sculpture standing in the entrance hall of Luton Central Library, representing the value of reading. It was presented by Vauxhall Motors Ltd and unveiled on 10 February 1965. The legend reads: He that loves reading has everything within his reach. (*Luton News*)

IMAGES
of England

LUTON

Mark Stubbs

TEMPUS

**LUTON LIBRARIES, INFORMATION
AND COMMUNICATIONS SERVICE**

First published 1997
Reprinted 2000, 2004
Copyright © Luton Borough Council, 1997

Tempus Publishing Limited
The Mill, Brimscombe Port,
Stroud, Gloucestershire, GL5 2QG

ISBN 0 7524 1086 5

Typesetting and origination by
Tempus Publishing Limited
Printed in Great Britain by
Midway Clark Printing, Wiltshire

For Penny

Contents

Acknowledgements

I wish to thank the following who have kindly lent photographs for inclusion in this book or given permission for their photographs to be reproduced: E.G. Meadows, Mrs M. Hammond, ABB Kent PLC, Electrolux UK Ltd, Vauxhall Motors Ltd, SKF (UK) Ltd, AEEU, Hunting Aerofilms Ltd, Laporte PLC, Home Counties Newspapers.

I have attempted to contact the copyright owners of all copyright photographs used in this book. This has not always been possible, however, as in many instances I have no information concerning the source of a photograph or its copyright owner. I would encourage anyone to contact me at Luton Central Library if they can demonstrate that I have used their copyright material without permission.

Introduction

Luton came to prominence in the nineteenth century primarily because of the hat industry. At the beginning of the century this was largely a cottage industry with plaiting tending to be done in the rural areas and the sewing concentrated in the town. In 1826 Richard Vyse, a London hatter, set up a hat factory in Luton. This was followed by many others, but at this time sewing was still done by hand and it was not until the 1870s that the use of sewing machines became widespread. The making of felt hats locally also began in the 1870s and this gave a boost to the trade, as felt hats, unlike straw hats, were suitable for winter weather.

The growing industry centred on George Street with the factories and warehouses being built there and in the adjoining streets. In 1895 there were some twelve hat factories, five hat warehouses and twenty-two straw plait warehouses. In 1869 Plait Halls were opened in Waller Street and Cheapside to enable the traditional market to move from George Street. However, with the decline of local plaiting and increased importation they soon became redundant and came to be used for public meetings, exhibitions and recreation. The first showing of a film in Luton took place there on Boxing Day 1896. The Plait Halls were later converted into a covered market which remained there until 1972 when the buildings were demolished to make way for the Arndale Centre.

In 1876 Luton became a borough and William Bigg, the town's first mayor, founded a local branch of the Chamber of Commerce. Although the hat trade was not Luton's only industry, agriculture, brewing and building also being important, there was a concern in the Council and the Chamber of Commerce that there was too much reliance on it, vulnerable as it was to changes in fashion and the export trade. In order to attract new industries a committee was set up to promote Luton as a desirable location for business. Advertised benefits included cheap electricity, low rates, available land and the railway.

From the end of the last century up until the First World War a number of new firms came to Luton and set up factories including Laporte's, the Co-operative Wholesale Society, Davis Gas Stove Company, Vauxhall Motors, Commercial Cars, George Kent and Skefco Ball Bearing Company. Between the wars Electrolux and Percival Aircraft followed. They had a lasting impact on the town and its future development and ensured that it would continue to grow and prosper in the twentieth century as it had in the nineteenth. After the First World War, resulting in the loss of its overseas markets, and with the effects of the post-war depression, the hat trade declined substantially. Engineering in general and the motor industry in particular were to take over as the town's main employers.

By its nature this book is nostalgic, concentrating on a Luton that no longer exists. In the re-development of the town in the 1960s and 1970s Luton lost some of its historic streets, such as Williamson Street and Waller Street, while others, such as Bute Street and Cheapside, were cut in two. It is sad that many of the town's most attractive buildings, such as the Carnegie Library or the Grand Theatre, were demolished, resulting in an impoverished built environment. Yet in concentrating on the buildings with architectural merit that were demolished we tend to forget the many dilapidated buildings of no value that were also bulldozed.

Things change for the better as well as the worse. The creation of St George's Square in front of the Central Library in 1977 added a welcome green open-space to the town centre. The Arndale Centre is often criticised for taking the heart out of the town centre, but it must be remembered that when it opened it was the best of its kind in Europe and people would travel some distance to shop there. Its recent refurbishment has given it a new lease of life. The pedestrianisation of George Street, with its attractive street furniture, has made the area a pleasant place to shop or to sit and watch the world go by. The extension of the scheme to Market Hill and Park Street, with the promise of a fountain, performance area and street cafés, will further enhance the area. Further improvements to the town will come shortly with the completion of the leisure centre on the site of the Co-op store in Bridge Street and an arts and media centre in a former hat factory in Bute Street.

New vibrancy was brought to the town in 1993 when the College of Higher Education gained university status. Impoverished they might be, but the influx of students has brought money to the town and boosted the local economy. Luton's nightlife has been revitalised as students patronise the town's pubs and nightclubs. Bookbuyers also benefited when Hammicks opened a book shop in the Arndale Centre and W. H. Smith greatly extended its range of books.

Luton Airport, now formally London Luton Airport, continues to grow. In the last financial year it catered for some 2.6 million passengers. It has come a long way from its modest beginnings in the 1930s. There are plans to make access to the airport easier with a new rail and road interchange which will include a new station at Gipsy Lane to be known as Luton Parkway Station. It would seem to have a bright future ahead of it.

Over the years many people have migrated to Luton in search of work and a new life and have contributed to the town in various ways. People have come to Luton in significant numbers from Scotland, Ireland, Pakistan, India, Bangladesh and the Caribbean, and to a lesser extent from a number of other countries. They have left their mark on the town and helped to make it a multi-cultural, cosmopolitan place. Luton boasts an annual carnival which is now the biggest one-day carnival in Britain. That in itself is testimony to the vitality of the town and its people.

<div align="right">Mark Stubbs
Luton Central Library, August 1997</div>

One
Street Scenes

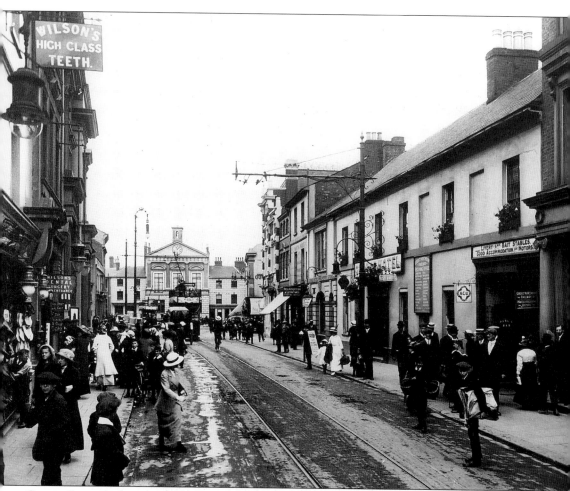

George Street looking towards the Town Hall, c.1910. The George Hotel is on the right. At the beginning of the century George Street was mainly concerned with the hat trade, containing a number of factories and warehouses, and Wellington Street was the main street for the retail trade.

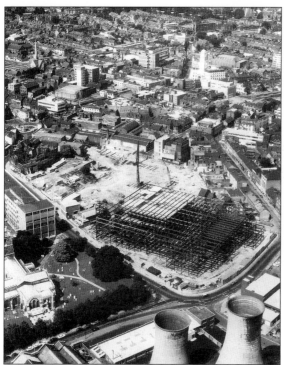

Aerial view looking west over the town centre, July 1970. In the centre can be seen the first phase of the Arndale Centre construction. To the left of this are St Mary's Church and the College of Technology, now the University of Luton. At the bottom right are the cooling towers of the electricity station. These were demolished in 1972 and the site became an industrial estate.(Hunting Aerofilms Ltd)

The town centre looking north, 1963. In the centre is the Town Hall and behind it in Gordon Street is the Ritz Cinema, originally the Union Cinema. To the right of the Town Hall is the Carnegie Library shortly before it was demolished and beyond that the new Central Library which opened the previous year. On the bottom left is King Street Congregational Chapel. (Hunting Aerofilms Ltd)

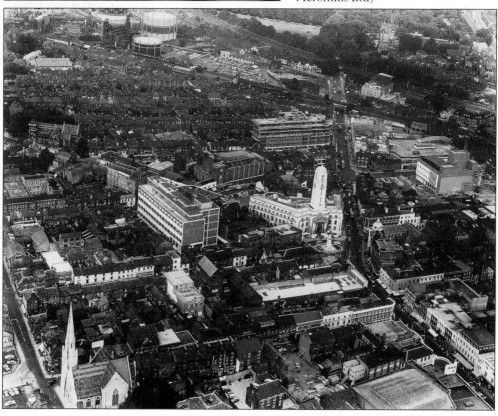

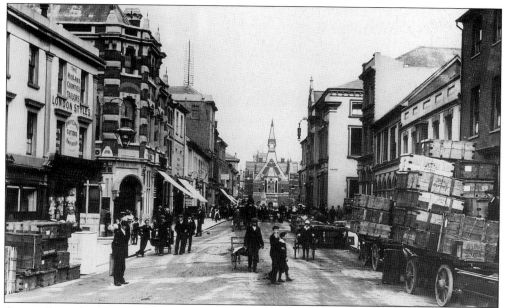

George Street looking towards the Corn Exchange, 1905. The drays are loaded with hat crates due to be dispatched from the station of the Great Northern Railway at Bute Street.

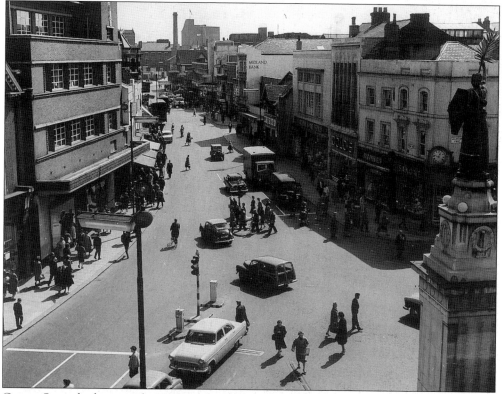

George Street looking south east from the Town Hall, 1959. The chimney and buildings on the top left belong to the Flower's Brewery in Park Street West, formerly J. W. Green's Phoenix Brewery. (E.G. Meadows)

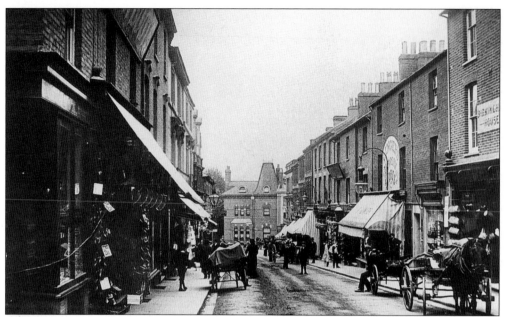

Wellington Street looking towards George Street, before 1910. The house visible on George Street belonged to Dr Horace Sworder, a popular doctor and the son of the brewer Thomas Sworder. For thirty years he was Borough Medical Officer of Health.

Wellington Street in the 1960s. The Ceylon Baptist Chapel is to the right of the shops. It opened in September 1847 and is said to have got its name from a former pastor who left to become a missionary in Ceylon, now Sri Lanka, in the early 1900s. Luton Girls' Choir grew out of its Sunday school choir.

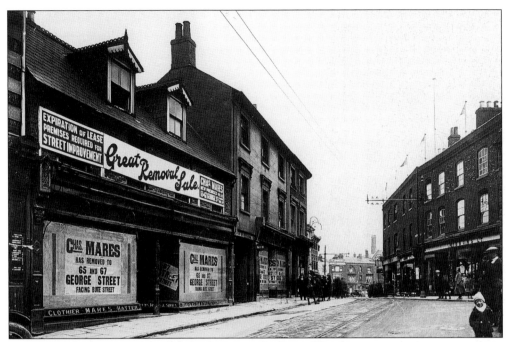

Market Hill looking towards Park Square, c. 1925. (*Luton News*)

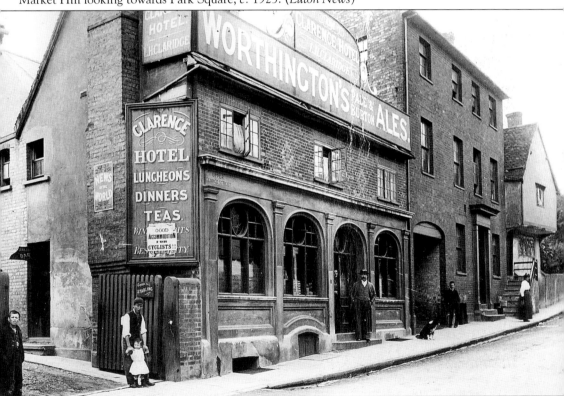

Dunstable Lane, later to become Upper George Street, 1895, showing the Clarence Hotel and Peddar's House.

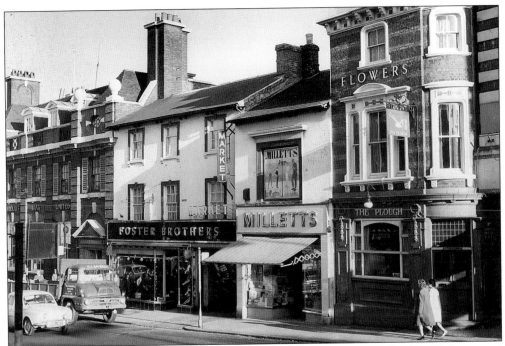

Market Hill, October 1963, showing Barclay's Bank on the site of the Waller family's house and The Plough public house. Notice the glazed relief of the plough under the ground floor window. (E.G. Meadows)

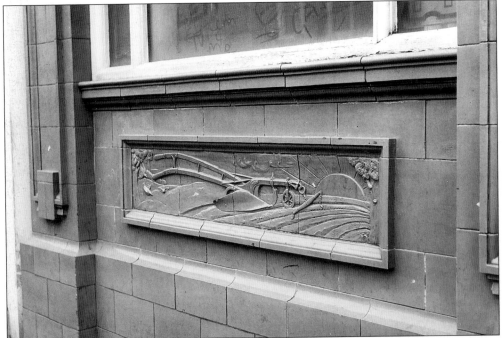

A close-up of the glazed relief from The Plough. When The Plough was demolished in the 1970s the relief was saved and is now prominently displayed in the restaurant of Debenham's department store which stands on the site. (E.G. Meadows)

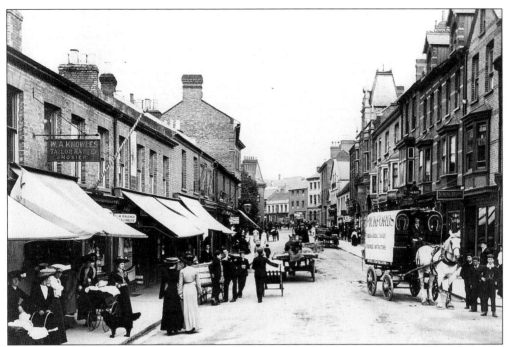

Manchester Street looking towards George Street, 1906. (W.H. Cox)

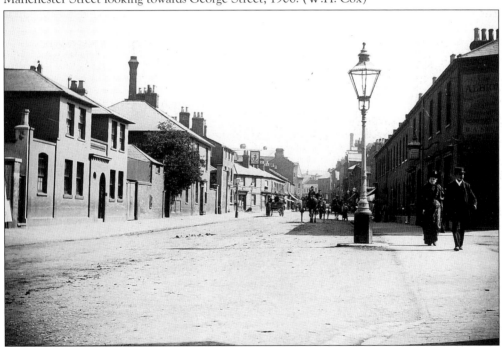

Manchester Street looking towards George Street from the corner of Alma Street, late 1890s. On the left is the sign of The Crown and Anchor public house and the chimney belongs to the brewery attached to it. J.W. Green took them over from Thomas Sworder in 1897 and demolished the brewery shortly afterwards. The public house continued to trade for many years but was eventually demolished in 1975.

The corner of Alma Street and New Bedford Road, early twentieth century. The Alma Cinema was built here, opening at Christmas 1929.

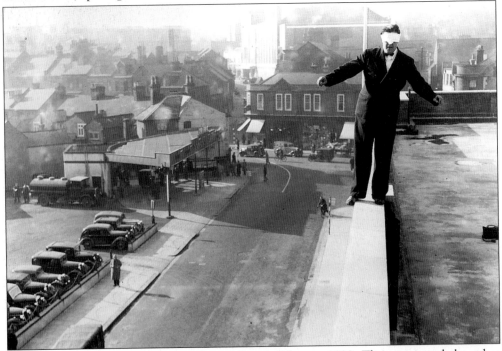

Bridge Street looking towards Manchester Street, February 1939. The garage and the other buildings on the left are on the site of St George's Square. The blindfolded balancer is on the roof of Dickinson and Adams' garage which later became the Co-op department store and was demolished in 1992. (*Beds and Herts Evening Telegraph*)

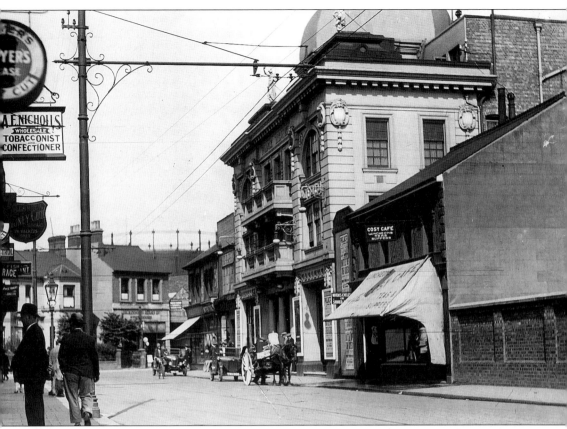

Mill Street, *c*.1930, showing the Palace Theatre on the right.

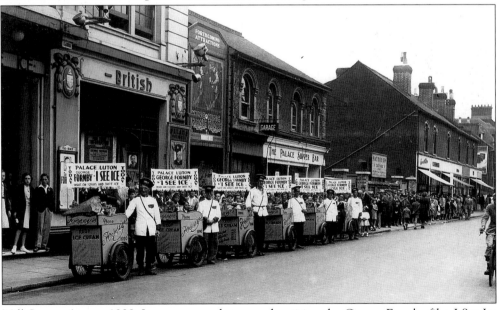

Mill Street, August 1938. Ice-cream vendors are advertising the George Formby film *I See Ice* outside the Palace Theatre.

Stuart Street looking towards Chapel Street, July 1967. On the left is the former magistrates' court. The spire is of the King Street Congregational Chapel. Shortly afterwards the buildings on the right were demolished to allow for the construction of the ring road. (E.G. Meadows)

Castle Street from the corner of Victoria Street, January 1968. All the buildings in the picture were demolished soon afterwards to provide the site for the ring road roundabout. (E.G. Meadows)

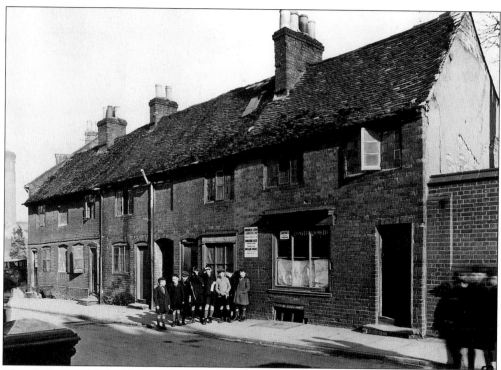

Church Street, 1927, showing the terraced houses on the churchyard side of the street. They were late sixteenth-century cottages which were converted into tenements in the late eighteenth century, re-fronted in around 1840 and demolished in 1927. (F Thurston)

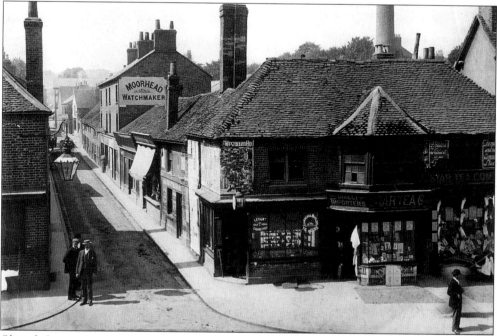

Chapel Street at its junction with George Street, c.1890, showing the side of the street demolished in the road widening of 1896. (F. Thurston)

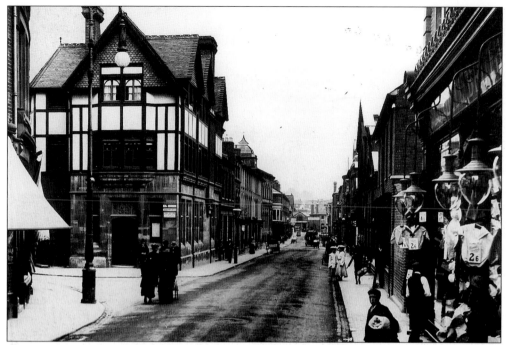

Cheapside looking towards Guildford Street, c.1906. On the left is Luton's original Head Post Office built in 1881. The Post Office moved to a new site in Upper George Street in 1923. The original building became a butcher's shop and was demolished in 1973. Above the buildings on the left can be seen one of the pinnacles of the Wesleyan Methodist Chapel in Waller Street. (W.H. Cox)

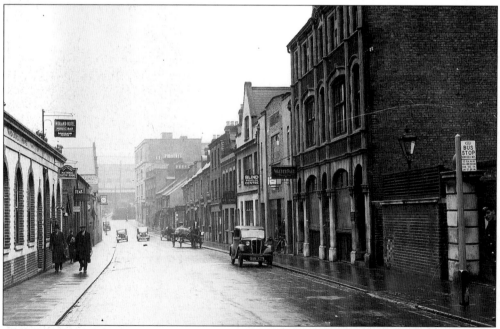

Williamson Street looking towards Guildford Street and Bute Street Station warehouse in the 1930s. On the left is the public bar of the Midland Hotel.

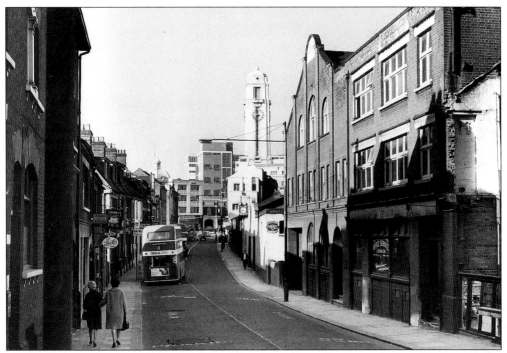

Williamson Street looking towards George Street, April 1962. The Town Hall is in the centre and on the corner of the road on the left is the Carnegie Library with its distinctive cupola. The premises of hat manufacturers are on both sides of the street, those on the right soon to be demolished to make way for a new bus station. (E.G. Meadows)

Cromwell Road, *c.* 1939, showing a coal delivery wagon and a child playing. (*Luton News*)

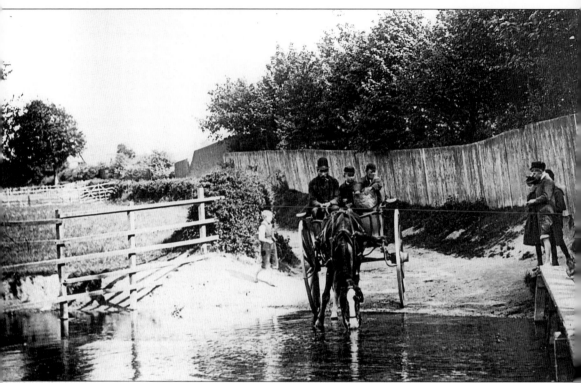

A ford crossing the River Lea at the bottom of Stockingstone Lane, formerly Champkins Lane, c.1890.

Stockingstone Lane newly completed and Montrose Avenue under construction, 1922.

Two
Retailing and Commerce

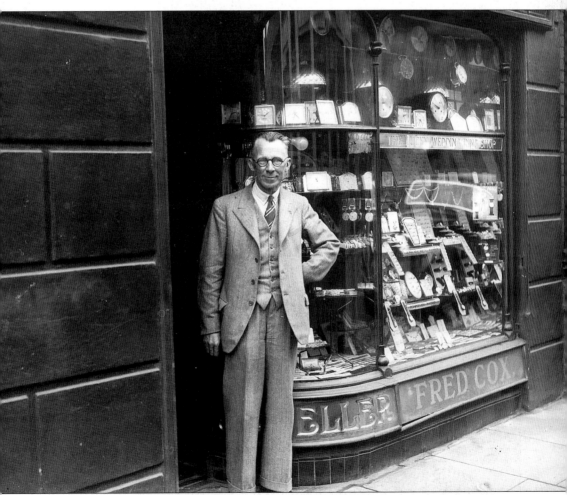

Fred Cox, jeweller and clockmaker of 15 Guildford Street, photographed on the occasion of a fire in his shop in September 1938. (*Beds and Herts Evening Telegraph*)

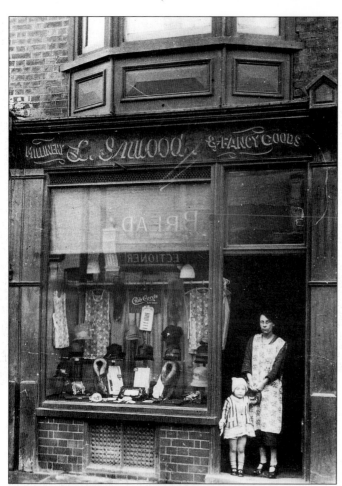

L. Inwood's millinery shop, High Town Road, *c.*1927.

General store and off licence, possibly at the corner of Midland Road and Gillam Street, *c.*1935.

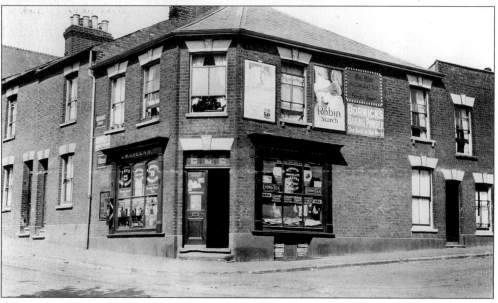

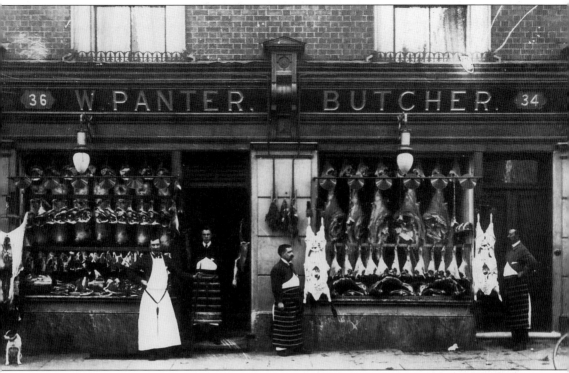

W. Panter, butcher, 34-36 Park Street, *c*.1900. (T.G. Hobbs)

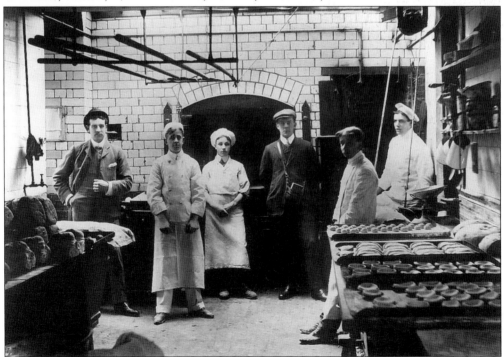

A Luton bakery, *c*.1914, possibly Redrup and Starkins' which had been founded as the North Ward Hygienic Bakery by Fred Redrup in 1850.

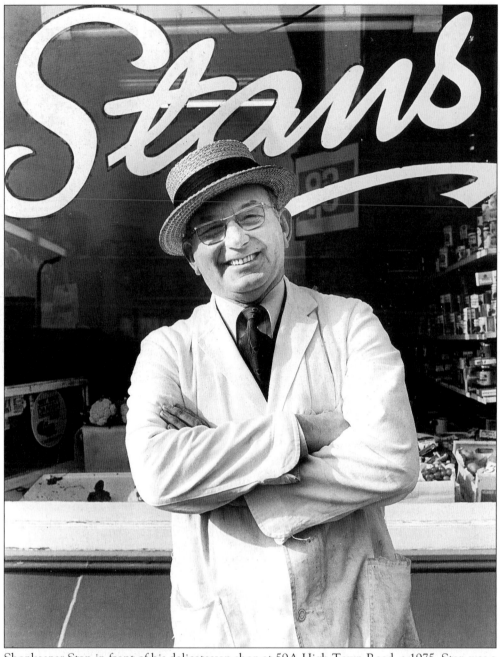

Shopkeeper Stan in front of his delicatessen shop at 59A High Town Road, c.1975. Stan was a popular local character who died in 1980.

Opposite: Arthur Pigott, butcher, 27 George Street, on the corner of Chapel Street, c. 1900.

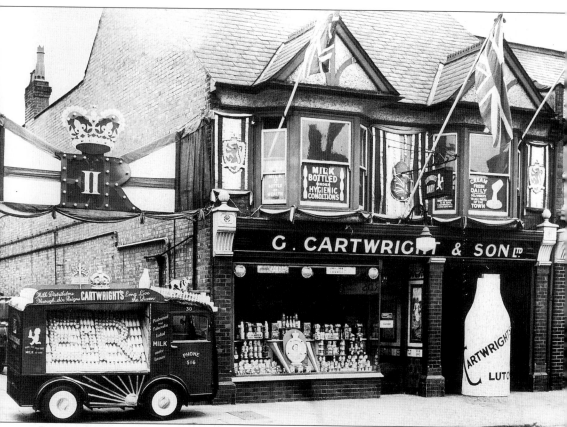

G. Cartwright and Son Ltd, 181-185 Dunstable Road, 1953. The premises and delivery vehicle are decorated for the Coronation.

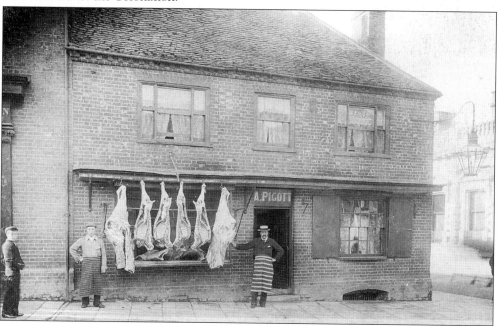

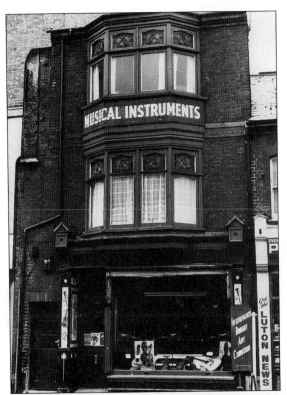

Bone and Co. musical instrument shop, New Bedford Road. Philip Bone was a teacher of musical instruments and in 1896 founded what was to become the Luton Mandolin Band. The shop is currently empty but was most recently a hairdressing salon. The decorative tiles showing various musical instruments, visible on the shop front, still survive.

Scene of an accident involving a Midland Railway dray outside Button Bros tailors and outfitters at the corner of George Street and George Street West. The premises were replaced by the Savoy Cinema in 1938, now the ABC. (*Luton News*)

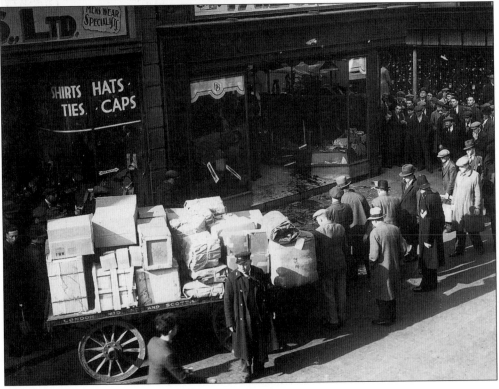

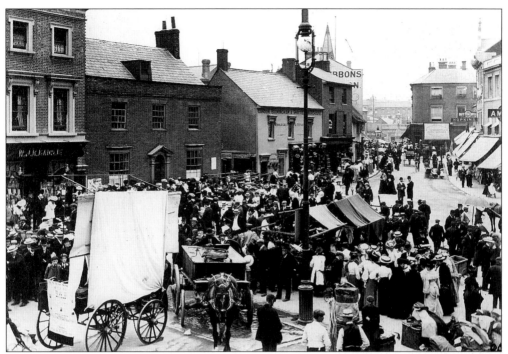

Park Square on a market day looking towards Market Hill and George Street, 1906. The weekly Monday market spread from Park Street to Market Hill. (W.H. Cox)

View from Market Hill to Park Square on a market day, 1906. In the centre background is the White House, the home of the Burr family, who at the beginning of the nineteenth century owned the town's largest brewery. The University of Luton is now based on this site. (W.H. Cox)

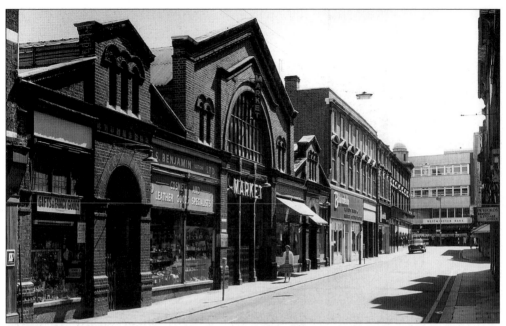

Cheapside looking towards George Street, *c*.1968. The building on the left was one of the two plait halls constructed in 1869, the other adjoining it in Waller Street. They were converted into a market in 1925 when the open air street market was re-located. The market was closed at the end of 1972 and moved to its current location in the Arndale Centre. The former plait halls were then demolished. (E.G. Meadows)

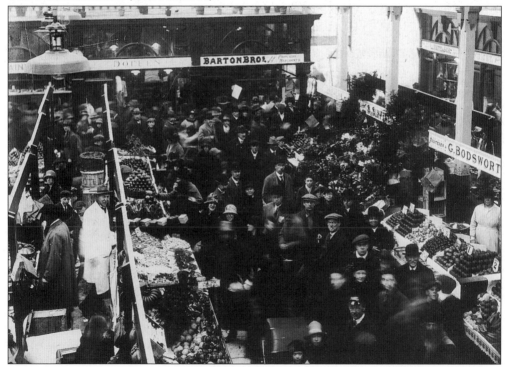

Opening day of the market, 1925. (*Luton News*)

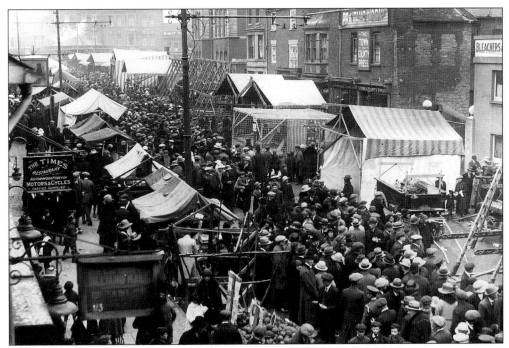

The April Fair in Park Street, 1922. A fair and cattle market was held in Park Street and Park Square on the third Monday in April each year and was known as the 'Statty Fair'. It was so disruptive to the normal business of the town that it was abolished in 1929. (*Luton News*)

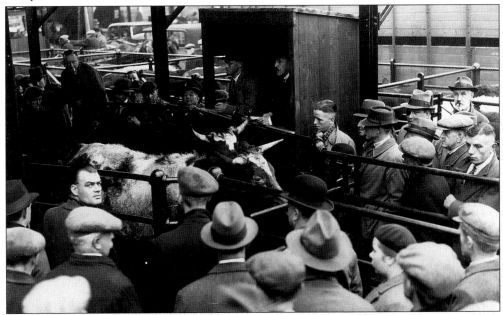

The cattle market, Bridge Street, January 1937. A weekly cattle market was held in Castle Street until 1899 when it moved to the site of the old Crown and Anchor brewery on Bridge Street, later the site of the Co-op department store and currently being re-developed as a leisure centre. In 1937 the market moved to a new site off Park Street where it stayed until it was finally closed in 1959. (*Luton News*)

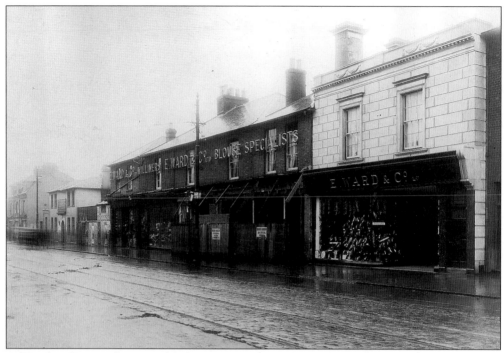

E. Ward and Co. milliners and ladies' outfitters, 2-20 New Bedford Road. The premises were taken over by the Co-op in 1927 and incorporated into its new shop.

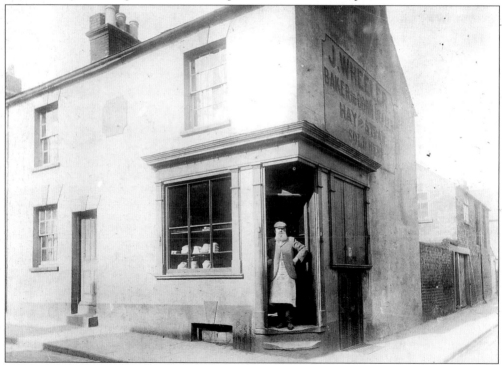

J. Wheeler, baker and corn dealer on the corner of Duke Street and Taylor Street, *c.*1890. John Wheeler is standing in his doorway.

Three
Industry

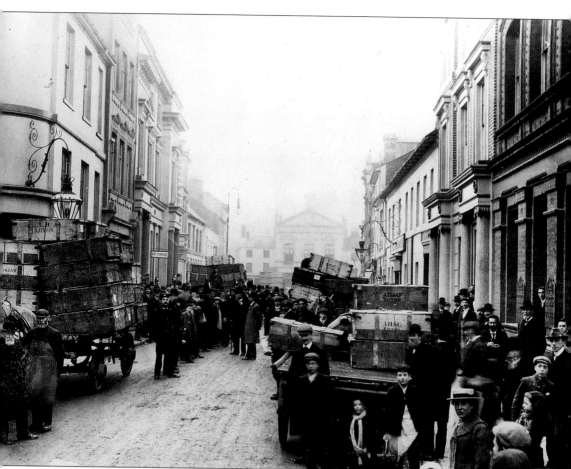

George Street, c.1905, showing railway carts loaded with hat crates. In the centre, wearing a buttonhole, is Asher Hucklesby, the town's largest hat manufacturer and five-times mayor. Next to him is George Warren, also a hatter and twice mayor. (T.G. Hobbs)

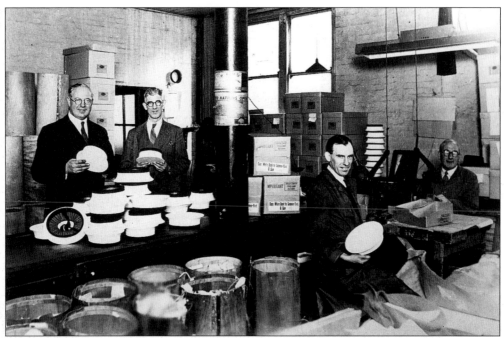

Sailors' hats being packed ready for dispatch at Sanders and Brightman's hat factory, Bute Street, *c.* 1950. The straw hat trade was established in the Luton area by the end of the seventeenth century. At the beginning of the nineteenth century it was still largely a cottage industry. It was relatively late to mechanise, with sewing machines only becoming widespread in the 1870s.

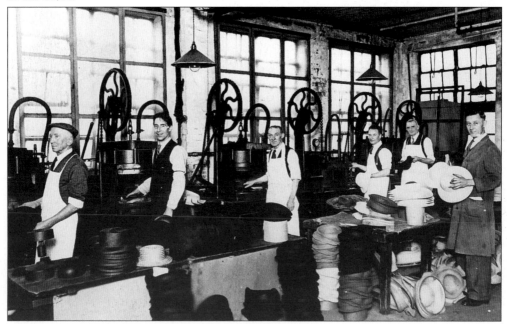

The hydraulic blocking room at Sanders and Brightman's factory, *c.* 1950. The making of felt hats in Luton began in the 1870s. The first factory was established in 1877 by the Carruthers brothers who moved to Luton from Scotland.

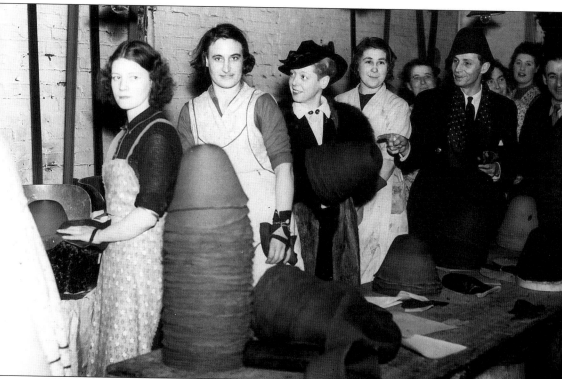

Luton hat workers at an unidentified factory, 1938.(*Luton News*)

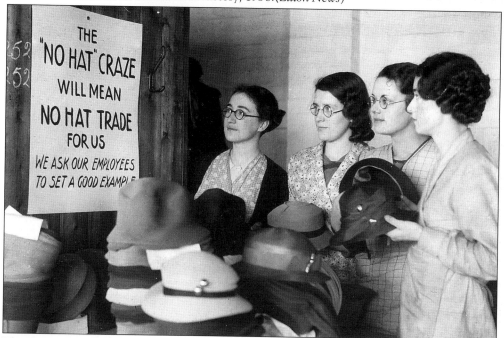

THE "NO HAT" CRAZE WILL MEAN NO HAT TRADE FOR US WE ASK OUR EMPLOYEES TO SET A GOOD EXAMPLE

The hat industry depended more than most on the vagaries of fashion and when this photograph was taken, *c*.1940, the trend towards fewer men and women wearing hats was already noticeable. (*Luton News*)

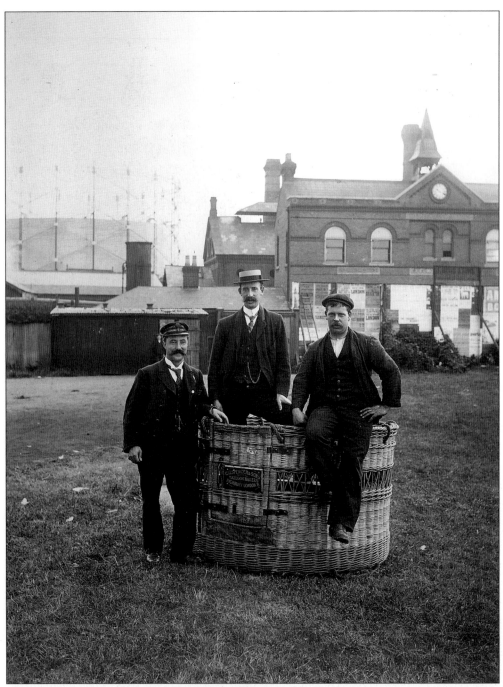

Three men posing with a balloon basket at the Luton Gas and Coke Company premises, Dunstable Road, c.1900. The company was founded in 1834 and brought gas lighting to the town for the first time. The site was cleared in the 1970s and the West Side Shopping Centre built on it. This was short-lived and was in turn demolished in the 1990s to make way for a Sainsbury's superstore. (A.J. Anderson)

Luton Gas and Coke Company's office, Dunstable Road, 1964. By this date the industry had been nationalised and the company had become a part of the Eastern Gas Board, but the original company's motto *Ex Fumo Dare Lucem* ('out of smoke came light') could still be seen above the door in the centre of the building.

The cooling towers of the electricity generating station in St Mary's Road, viewed from the churchyard, *c.*1943. The power station was opened in 1901 on the site of the former vicarage gardens. The availability of cheap electricity was one of the factors which attracted new industries to the town in the early 1900s. (*Luton News*)

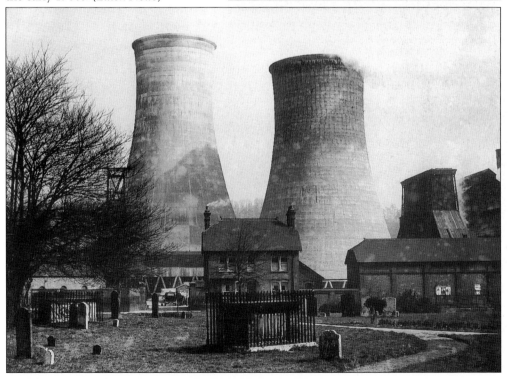

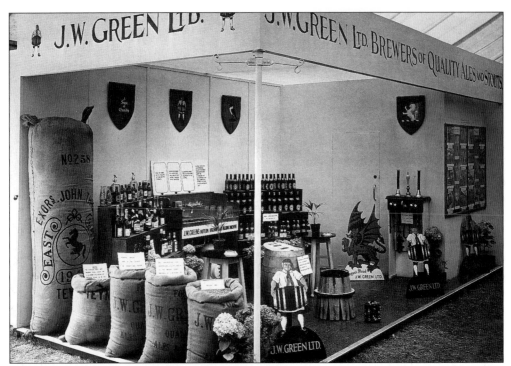

J.W. Green's stand at the Luton Exhibition, 1951. John W. Green (1847-1932) once controlled a large brewing empire formed by acquiring rival breweries. By 1950 the company was one of the largest brewers in the country. In 1954 it merged with Flowers, resulting in the loss of the J.W. Green name and in 1961 was taken over by Whitbread.

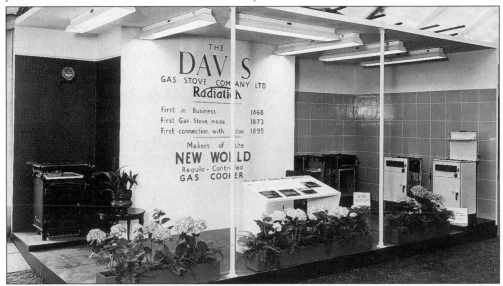

Davis Gas Stove Company at the Luton Exhibition, 1951. The company came to Luton in 1895 when it acquired the Langley foundry. In 1907 it opened the Diamond foundry in Dallow Road, its name coming from the company's Diamond gas cooker which had been launched in 1897, the year of Queen Victoria's Jubilee. The company later became part of Jackson Industries and closed its Dallow Road works in 1962.

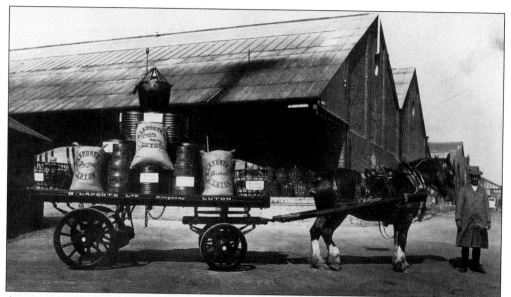

A promotional photograph for B. Laporte Ltd showing the company's range of products, *c.* 1925. Bernard Laporte began producing hydrogen peroxide, a chemical used in the hat industry for bleaching straw, in Shipley, Yorkshire, in 1888. In 1898 he moved his company to Luton at a time when there was an increasing demand for chemical bleaches and dyes from Luton's prospering hat industry. The company continued to produce chemicals in the town until 1985. (Laporte PLC)

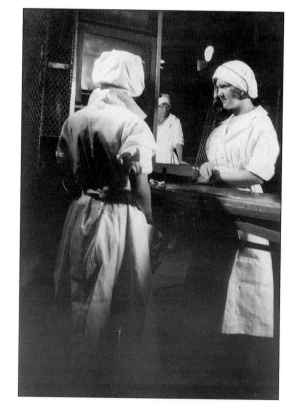

Manufacturing chocolates at the Co-operative Wholesale Society (CWS) cocoa and chocolate factory, Dallow Road, in the 1930s. The factory was built in 1902 and was known locally as the cocoa works. It gave to the surrounding area an unmistakable sickly-sweet aroma.(Hubert Hammond)

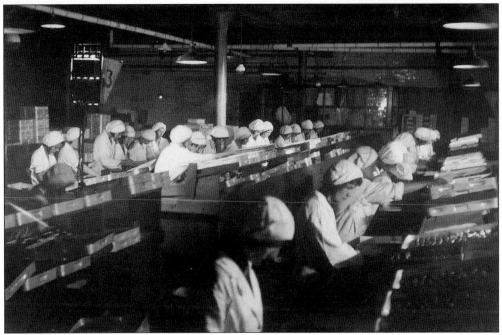

Packing the chocolates at the cocoa works in the 1930s. (Hubert Hammond)

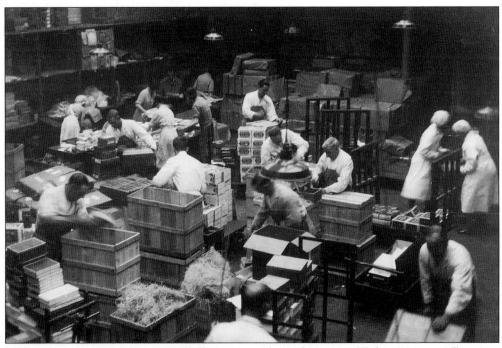

Packing the chocolates for export at the cocoa works in the 1930s. (Hubert Hammond)

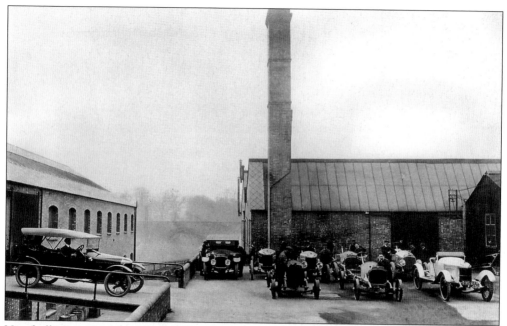

Vauxhall Motors' original works, Kimpton Road, c.1910. The motor industry came to Luton in 1905 when the Vauxhall and West Hydraulic Engineering Company arrived from London. Initially car production was small-scale, being a side-line to their main activity of manufacturing pumping machinery. Car production increased when Vauxhall Motors was formed as a subsidiary company in 1907. (Vauxhall Motors Ltd)

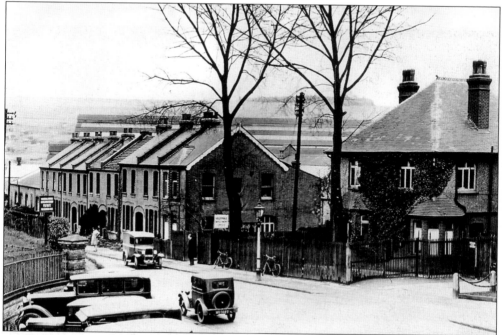

Kimpton Road, c.1910. The house on the right was purchased when Vauxhall first moved to Luton in 1905. For a time it served as the company's head office but was demolished in the 1920s and replaced by more suitable buildings. (Vauxhall Motors Ltd)

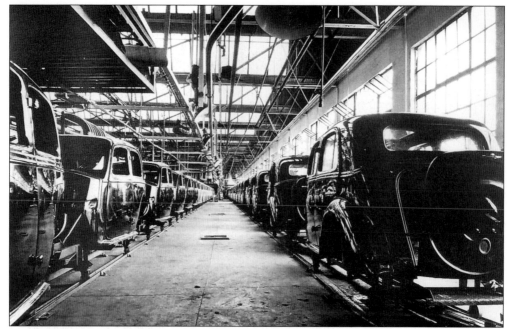

The Vauxhall production line, 1939. The car bodies on the left, coming towards the camera, are on their way to undergo paint and trim operations. Those on the right, heading away from the camera, have been through these operations and are on their way to be mounted. (Vauxhall Motors Ltd)

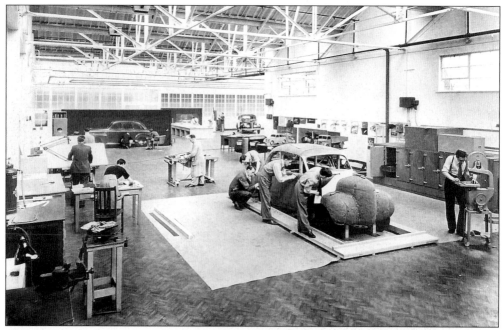

The Engineering Research Building, Vauxhall Motors, 1939. In this area the style, shape, trim and external features of future cars were developed. Chassis engineers and designers collaborated and produced mock-ups in clay and also in wood to show what each proposed new model would look like. (Vauxhall Motors Ltd)

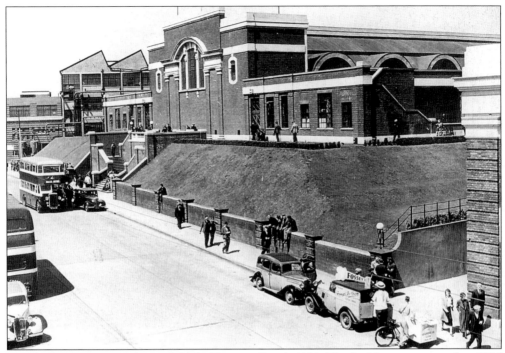

Vauxhall Restaurant and Social Club, Kimpton Road, 1939. The building was opened in 1936 and served as both a restaurant and as a venue for a variety of leisure pursuits out of hours. It was demolished in 1992. (Vauxhall Motors Ltd)

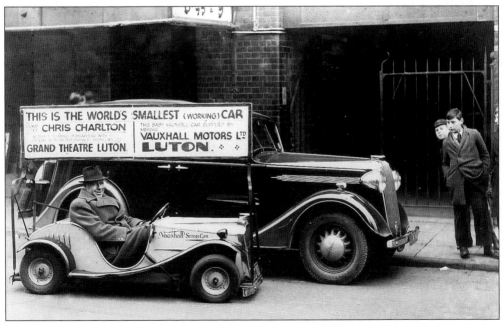

Claimed to be the world's smallest working car, the Vauxhall Scoota, on show outside the Grand Theatre, 28 November 1936. (*Luton News*)

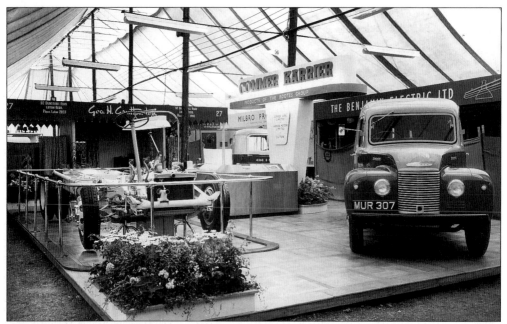

Commer Cars' stand at the Luton Festival, 1951. Commer Cars came to Luton in 1906, originally as Commercial Cars, and built a small factory in Biscot Road. They were later taken over by Humber Ltd which became part of the Rootes Group in 1928 and which was absorbed by Chrysler UK in 1970. The Biscot Road factory was demolished in 1985 and replaced by a housing development.

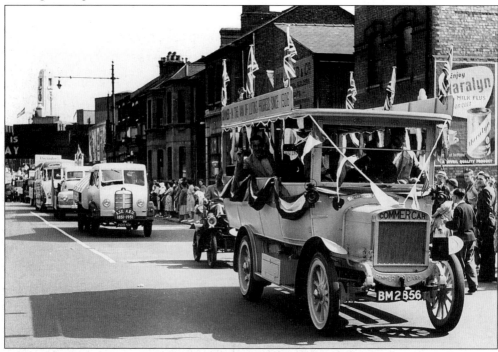

A Commer charabanc in New Bedford Road taking part in the procession to mark the centenary of the Amalgamated Engineering Union on 16 June 1951. (AEEU)

Kent Instruments, Biscot Road, 1970s. George Kent Ltd opened a factory at Biscot Road in 1908 and manufactured a variety of industrial measuring instruments. It was demolished in the 1980s. (ABB Kent PLC)

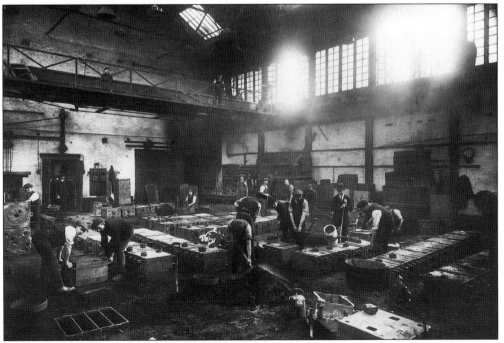

George Kent foundry, c. 1920. (ABB Kent PLC)

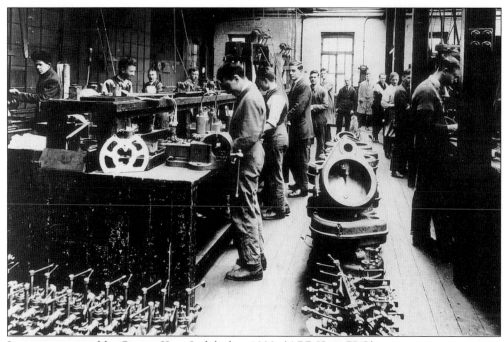

Instrument assembly, George Kent Ltd, before 1930. (ABB Kent PLC)

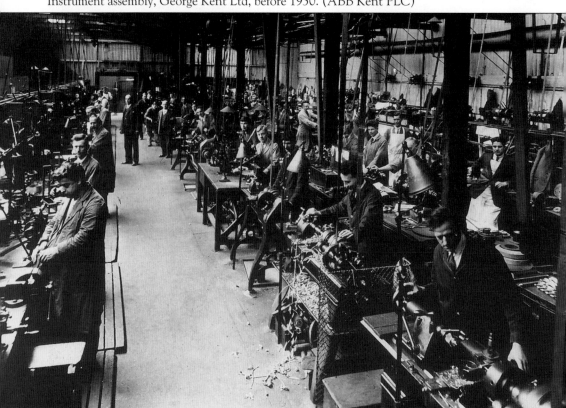

The instrument machine shop, George Kent Ltd, before 1930. (ABB Kent PLC)

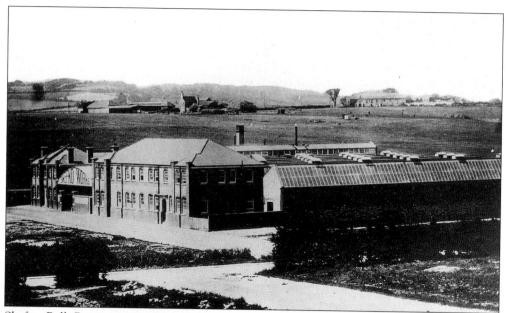

Skefco Ball Bearing Company's original factory, 1911. Skefco was formed in 1910, the subsidiary of a Swedish company. A factory was constructed in Skefco Road, off Leagrave Road and a second, larger factory was built in Sundon Park in 1942. It changed its name to SKF (UK) Ltd in 1973. (SKF (UK) Ltd)

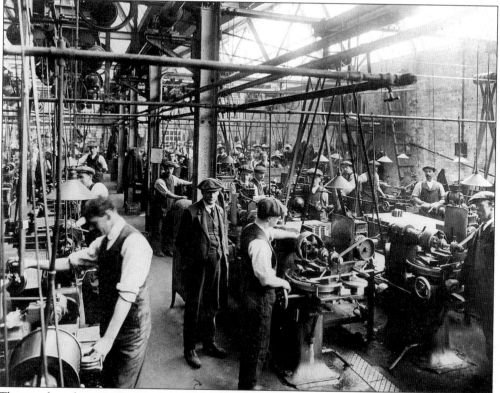

The grinding department, Skefco, 1915. (SKF (UK) Ltd)

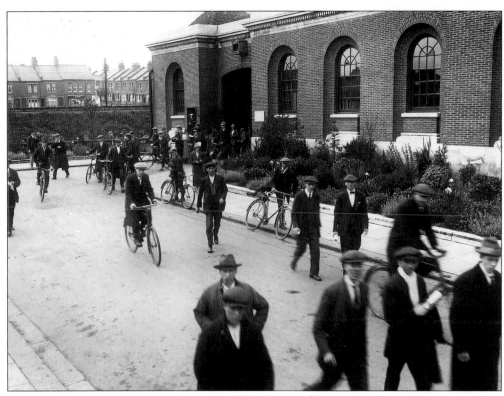

Skefco employees leaving the works, 1932. (SKF (UK) Ltd)

Demolition of houses to allow for the expansion of the original factory, June 1934. (SKF (UK) Ltd)

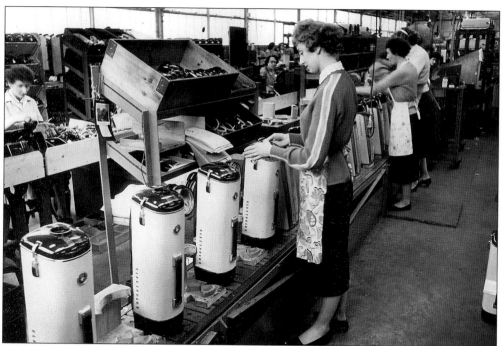

Assembling vacuum cleaners at the
Electrolux factory, Oakley Road,
October 1958. Electrolux's factory was
opened in May 1927 on the site of the
Hewlett and Blondeau's First World
War aeroplane factory. (Electrolux UK
Ltd)

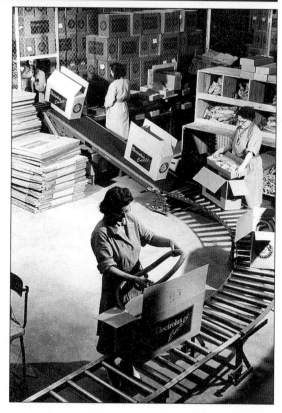

Packing the vacuum cleaners, October
1958. (Electrolux UK Ltd)

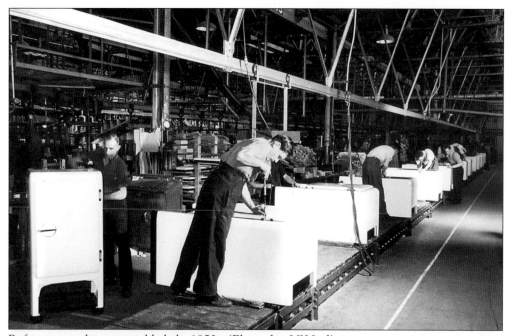

Refrigerator cabinet assembly belt, 1950s. (Electrolux UK Ltd)

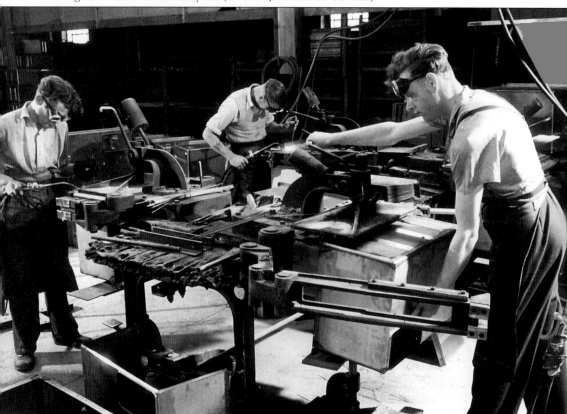

Welding linings for refrigerators at the Electrolux factory, 1950s. (Electrolux UK Ltd)

Four
Selected Buildings

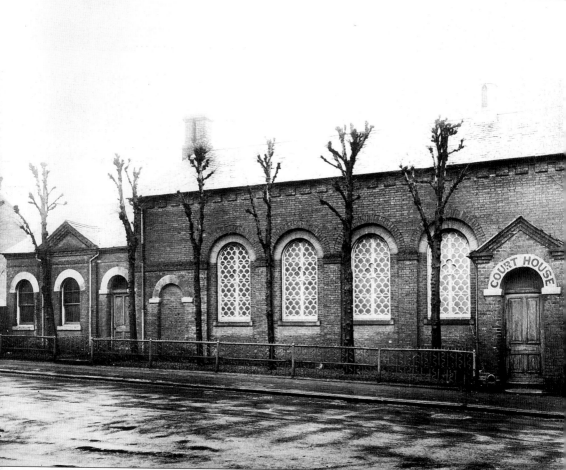

Luton Magistrates' Court, 54 Stuart Street. It was demolished in 1936 and replaced by a new court building on the same site.

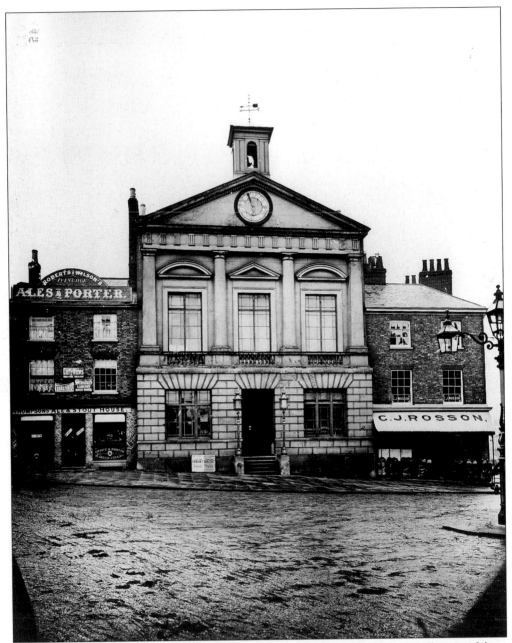

Luton Town Hall, 1880. The Town Hall was built in 1847 and was originally owned by a private firm, the Town Hall Company. In 1876 Luton gained the status of municipal borough and the new council took over ownership from the Board of Health, which had bought the Town Hall the previous year. The building was destroyed by fire during the Peace Day riot of July 1919 and replaced by the current Town Hall. (F. Thurston)

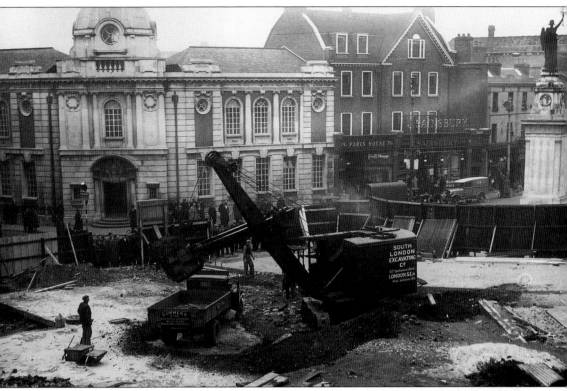

Excavating the site of the new Town Hall, 1935. The Carnegie Library is in the background. (*Luton News*)

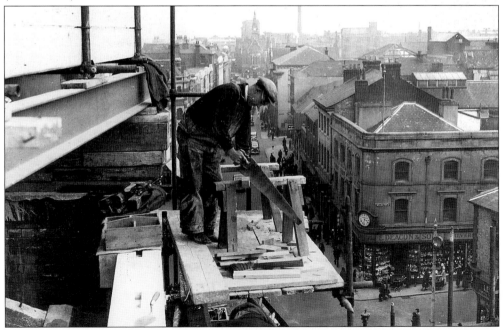

The new Town Hall under construction, 1936, showing the roofs of George Street looking towards the Corn Exchange. (*Luton News*)

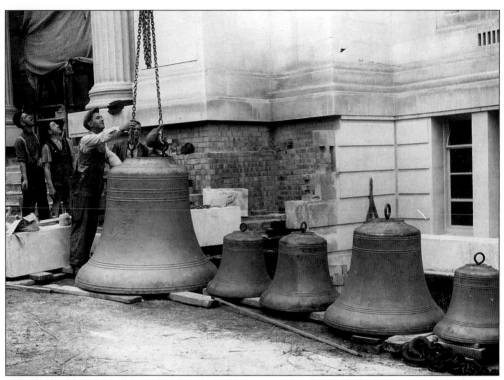

Bells for the Town Hall clock being hauled into position, 22 August 1936.(*Luton News*)

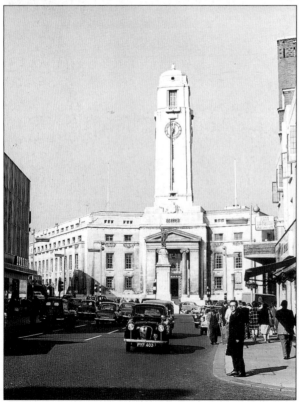

The Town Hall, 1950s. The new Town Hall was opened by the Duke of Kent on 28 October 1936, some seventeen years after the destruction of the previous one. Standing in front of the Town Hall is the war memorial commemorating the dead of the First World War; it was unveiled by Lady Ludlow on 10 December 1922. (*Luton News*)

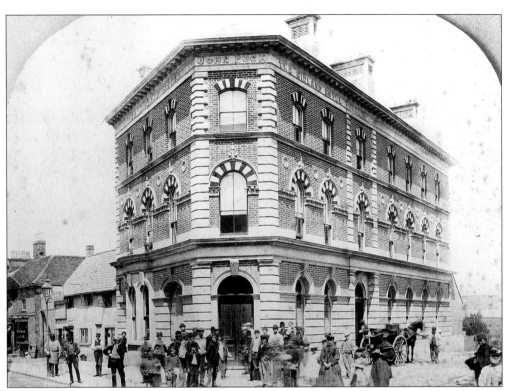

The Midland Hotel on the corner of Williamson Street and Manchester Street, c.1890s. On the left is The Horse and Jockey public house.

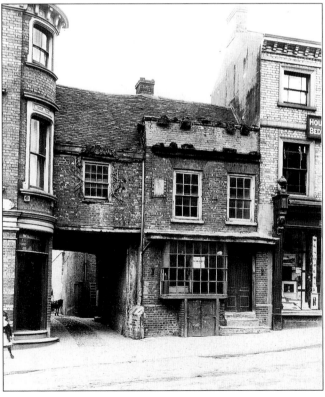

Seabrook's or Marsom's House, Market Hill, c. 1895. Thomas Marsom founded the Park Street Baptist Church at the end of the seventeenth century and this house served as the family's ironmongers shop. By the nineteenth century it was the premises of a corn merchant named Seabrook. It was pulled down in 1895 to allow Blundell's store, on the right, to expand. (F. Thurston)

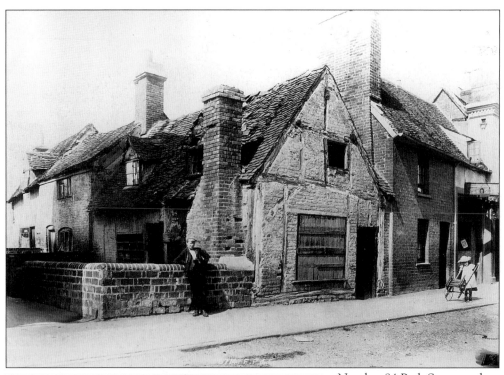

Number 84 Park Street at the corner of School Walk, formerly known as Black Water Lane because of its proximity to an effluent stream of sewage and chemical dye. The image dates from the late nineteenth century.

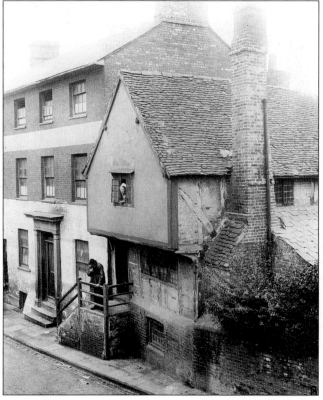

Peddar's House, Dunstable Lane, now Upper George Street, *c.*1899. A fifteenth-century farmhouse, one of the last in the town centre, it was demolished shortly after this photograph was taken and it was near here that the new Post Office was built in 1923. (F. Thurston)

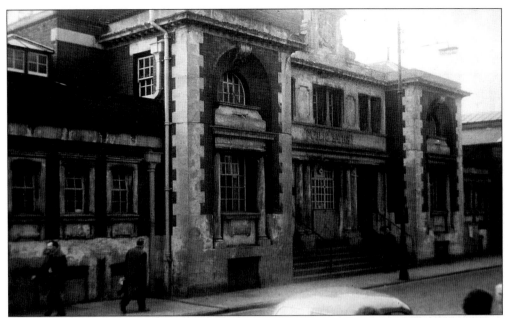

The Waller Street Public Baths. The baths were opened in 1913 and replaced the former baths on the same site. In the winter the pool was boarded over and the building was transformed into the Winter Assembly Hall, a venue for public meetings, concerts and dances. They stood next to the Plait Halls and opposite the Grand Theatre. They were closed in 1965, when the indoor pool opened in Bath Road, and demolished in 1970.

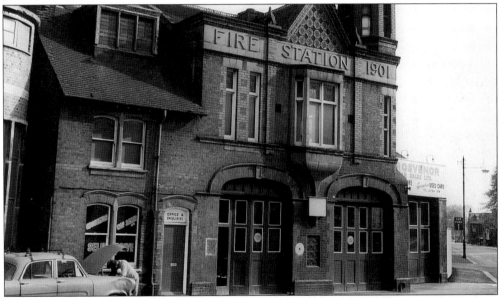

Luton Fire Station on the corner of Church Street and St Mary's Road, 1963. It was built in 1901 and was in use until 1952 when the fire service moved to temporary premises in Park Street on the site of the former bus station bombed in the Second World War. In July 1956 the new purpose-built station was opened in Studley Road. The old building was demolished in 1968. When this photograph was taken it was serving as the offices and showroom of Grosvenor Car Sales Ltd. (E.G. Meadows)

The old vicarage of St Mary's Church, 1898. In 1897 the new vicar, Edmond Mason, sold the vicarage to Luton Corporation which allowed the electricity works to be built on the former garden. These were opened by Lord Kelvin on 10 July 1901. The vicarage itself was demolished in 1907 when the works were extended. (F. Thurston)

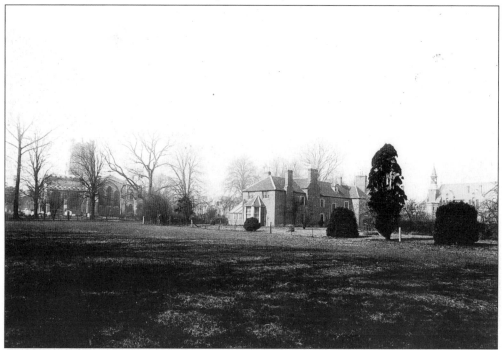

St Mary's Church, the old vicarage and St Mary's Hall, c. 1895. The hall was opened as a girls' school in 1892, closed in 1940 and demolished in 1968. (F. Thurston)

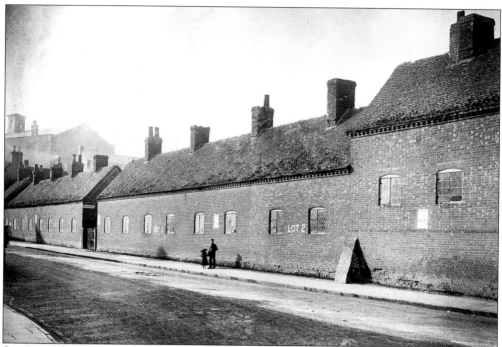

Seventeenth-century almshouses, Tower Hill, *c*. 1870. They were condemned as unfit for human habitation by the Board of Health, auctioned and then demolished. (F. Thurston)

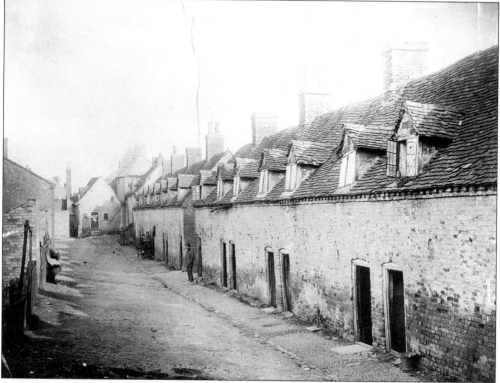

Rear view of the almshouses. (F. Thurston)

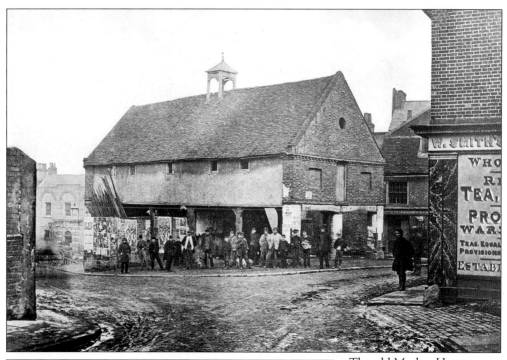

The old Market House,
Market Hill, 1865. The
original Market House was
demolished in 1867 and
replaced by the Corn
Exchange. (F. Thurston)

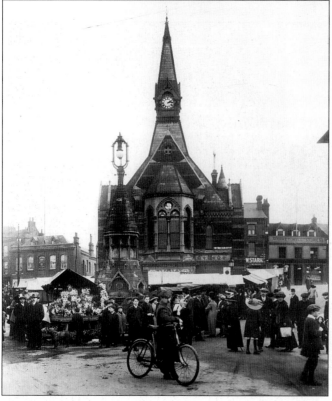

The Corn Exchange and
Market Hill, 1913. The
Corn Exchange was built in
1869 and came to be used
for a variety of purposes
including public meetings,
dances, concerts, exhibitions
and film shows. It was
demolished in 1951 because
it was structurally unsound.
In front of it stood a water
fountain known as 'the
pepperpot' erected in 1874
in memory of Lionel Ames.
It was demolished in 1925.
(W.H. Cox)

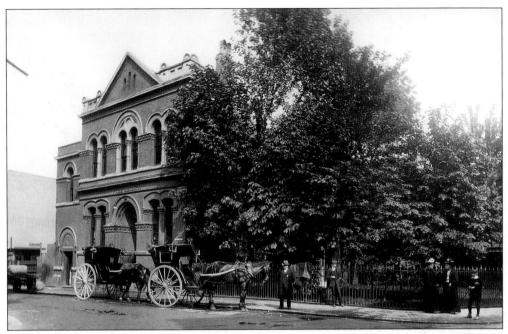

The Free Library, Williamson Street, *c*. 1907. This was Luton's first library, built in 1883. Initially under private management it was taken over by the Council in 1895 and demolished in 1909. (T.G. Hobbs)

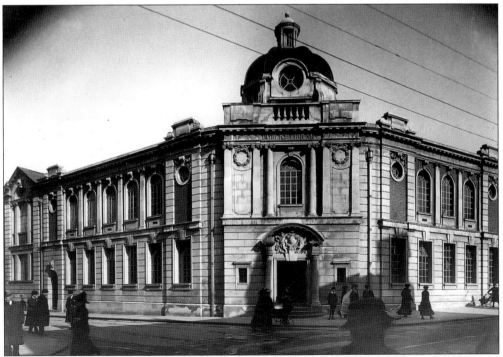

The Carnegie Library, 1910. This was given to the town by Andrew Carnegie who opened it in person in October 1910. In 1962 it was replaced by the new Central Library and demolished shortly afterwards. (F. Thurston)

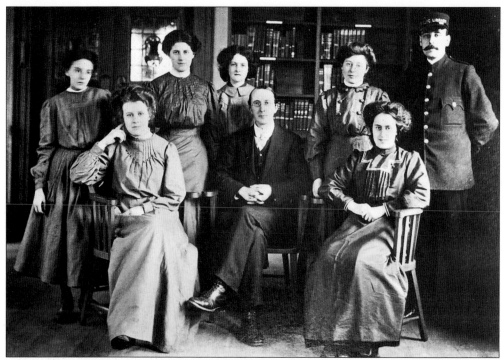

The original staff of the Carnegie Library. In the centre is the first librarian, Thomas Maw, who committed suicide in 1925 by taking cyanide. Seated next to him on the right is his assistant, Miss Griffiths, who was to take over as librarian. (F. Thurston)

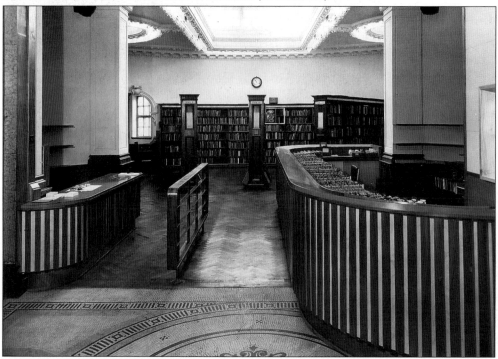

Inside the Carnegie Library, 1950s. (W.H. Cox)

Looking across St George's Square towards Lutin Central Library, 1982. Notice the mural depicting old Luton on the side wall of the library on the right of the building. (Luton Borough Council)

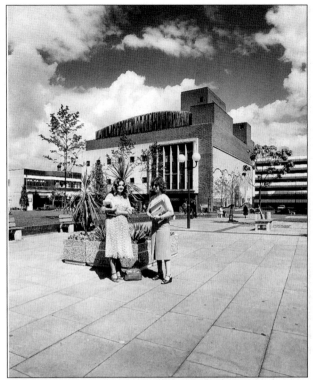

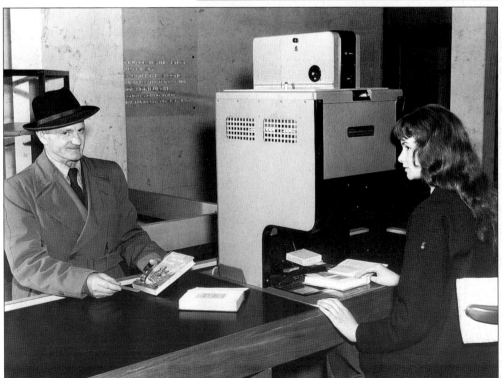

The photocharging issuing system inside the Central Library, 1963. (Waller Studios Ltd)

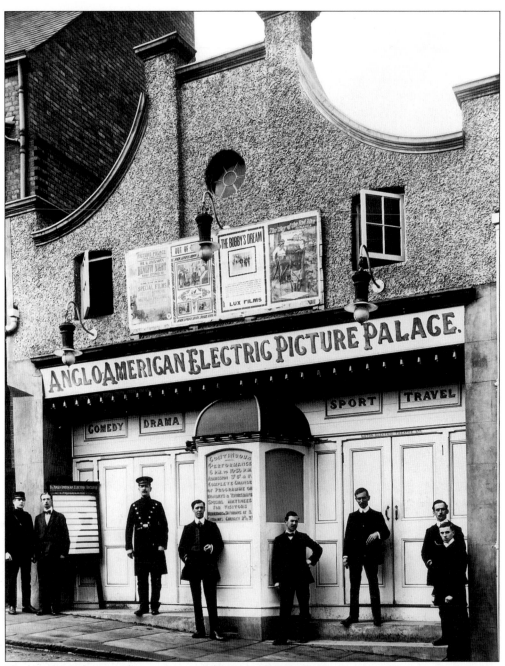

The Anglo American Electric Picture Palace, 12 Gordon Street, c. 1910. This was Luton's first cinema, opened on 16 October 1909, later to become the Gordon Street Electric Pavilion. On 15 October 1929 the cinema was badly damaged in an arson attack and closed. In April 1930 the building was sold and converted into a furniture shop.

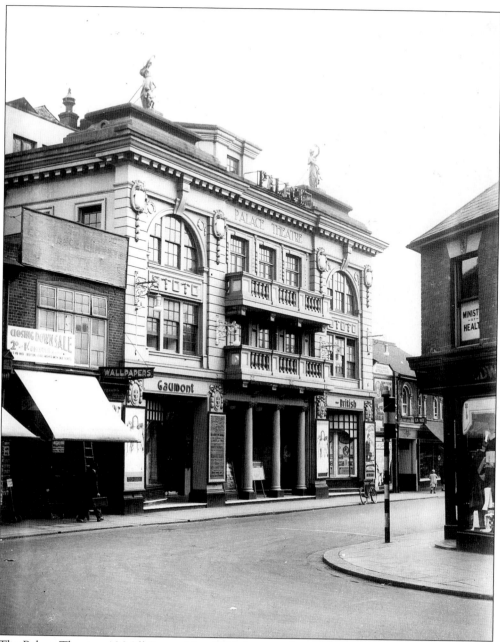

The Palace Theatre, 19 Mill Street, May 1934. It opened on 26 December 1912 and became the Gaumont Cinema in November 1949. It closed on 14 October 1961 and re-opened a year later as the Majestic Ballroom. It was destroyed by fire on 28 December 1982 and the site was cleared for a development of flats.

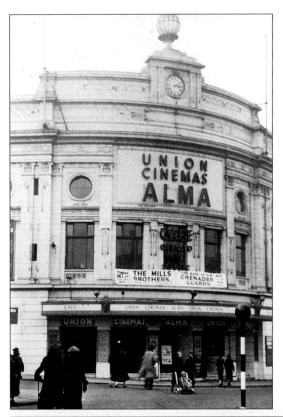

The Alma Cinema, on the corner of Alma Street and New Bedford Road, *c.* 1950. It opened in December 1929 as the Alma Kinema and closed in July 1954. It re-opened as the Alma Ballroom on 1 April 1955 and was renamed the Cresta Ballroom later that same year. In July 1960 it was demolished and replaced by shops and offices.

A performing horse and dog with their owner in the foyer of the Alma Cinema, 1930s. (*Luton News*)

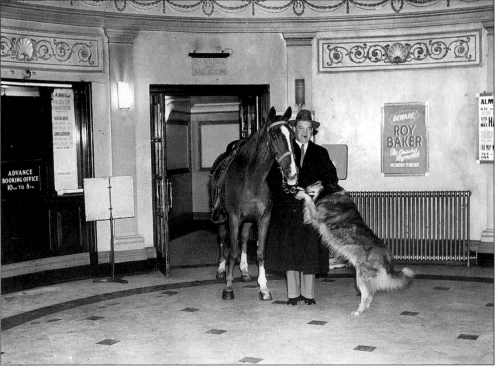

An Australian escapologist at the Grand Theatre, 25 Waller Street, 1935. The theatre was opened in 1898 by Lily Langtry and closed in 1957. It was later converted into a Tesco supermarket and was demolished in 1973.

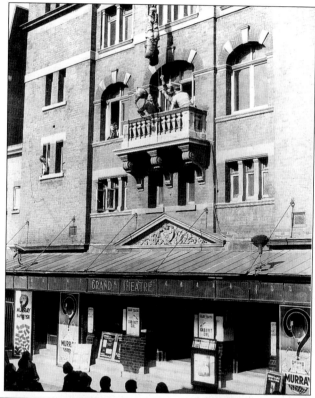

A commissionaire advertising the film *Forced Landing* at the Empire Cinema, 116 Bury Park Road, 1 August 1938. The Empire opened on 29 November 1921 in a former aeroplane propeller factory. It closed on 15 October 1938 and now serves as a synagogue. (*Luton News*)

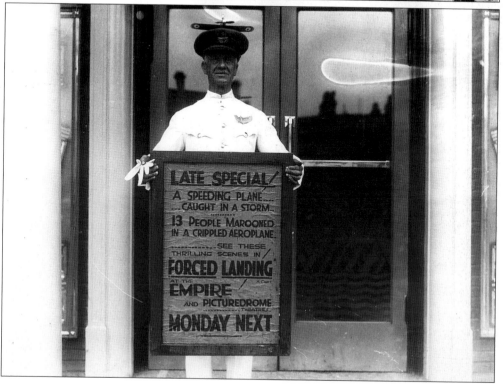

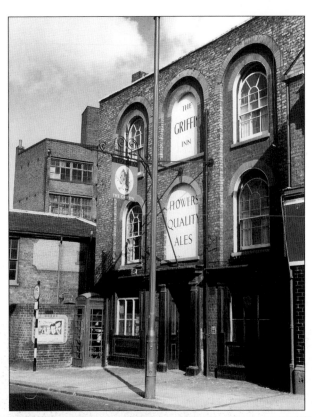

The Griffin Inn, 9 Chapel Street, September 1958. In 1980 it changed its name to The Bitter End. (E.G. Meadows)

The Crown Inn, 1 George Street, June 1968. In the 1980s it became The Nickel Bag and in 1995 it was re-named The Rat and Carrot. (E.G. Meadows)

Five
Transport

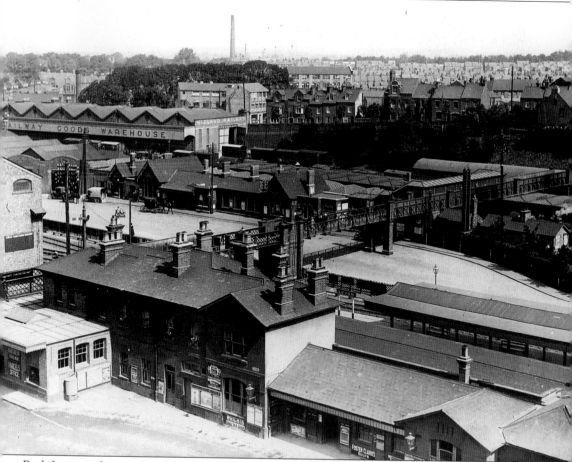

Both Luton railway stations in the early 1920s. In the foreground is the Bute Street Station and in the middleground is Station Road and the Midland Railway Station. The Luton, Dunstable and Welwyn Railway was the first of the two railways running through Luton and opened in 1858 with its station at Bute Street. It closed to passenger traffic in April 1965.

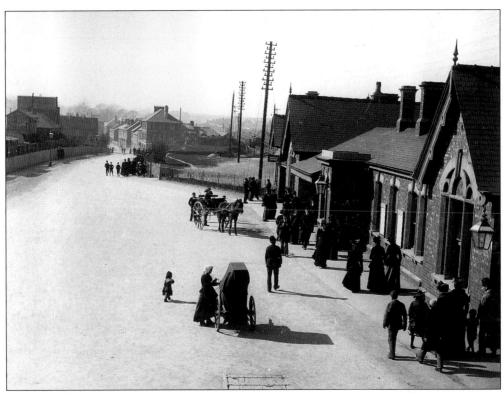

The Midland Railway Station, *c*.1900. The Midland Railway provided Luton with its second line and a direct link to London when the line was extended from Bedford. It opened to goods traffic in 1867 and to passengers the following year. The original station was replaced in 1937.

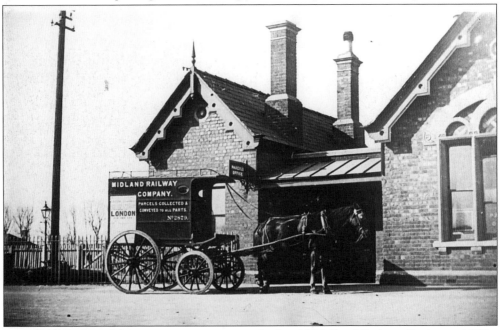

A Midland Railway delivery wagon waiting outside the old Midland Railway Station, *c*.1900.

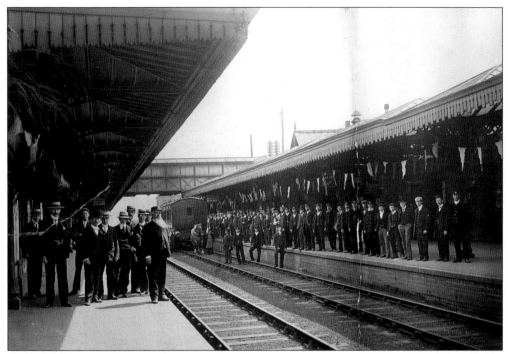

Turn-out of railway staff at the Midland Railway Station, late nineteenth or early twentieth century, possibly to greet King Edward VII. The station master, Sam Green, is the bearded man on the left. Notice the horse used for shunting.

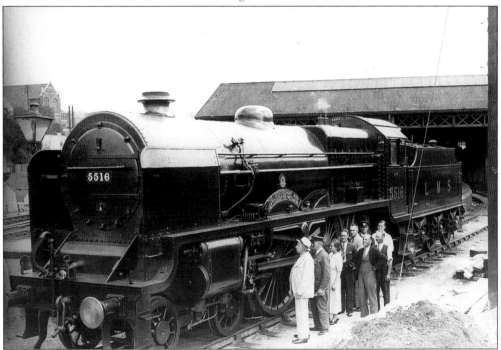

Midland locomotive number 5516, named *The Bedfordshire and Hertfordshire Regiment*, at the Midland Railway Station, 1938.

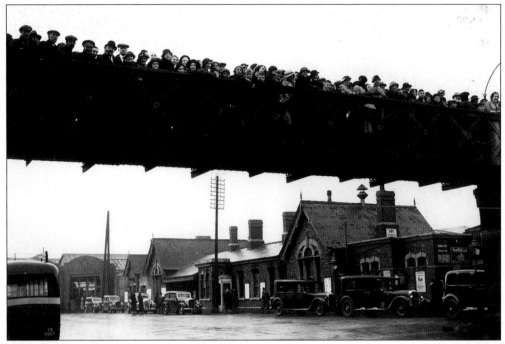

The Midland Railway Station, 6 November 1935, with a crowd waiting to see the honeymoon train of the Duke and Duchess of Gloucester. The bridge linked Midland Road with Bute Street allowing movement from one station to the other. (*Luton News*)

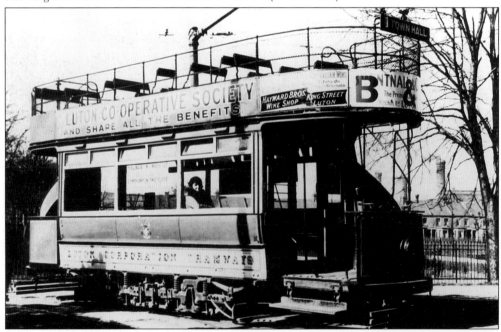

Luton tram, *c*.1927. Luton's tram system opened on 21 February 1908 with twelve trams in operation. They were open-topped and so not very pleasant in bad weather. In 1930 four of the trams had roofs fitted but this measure was not enough to save them. The last tram ran in Luton on 16 April 1932.

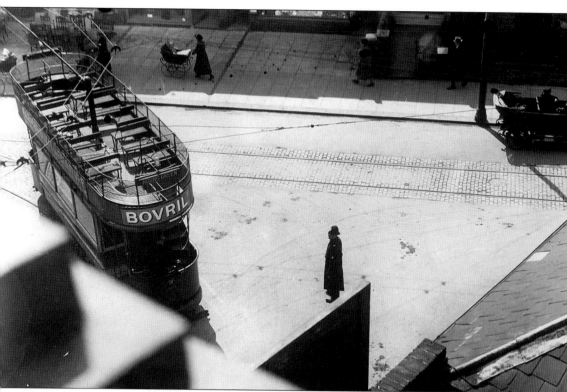

Tram turning into Mill Street from New Bedford Road in the 1920s.

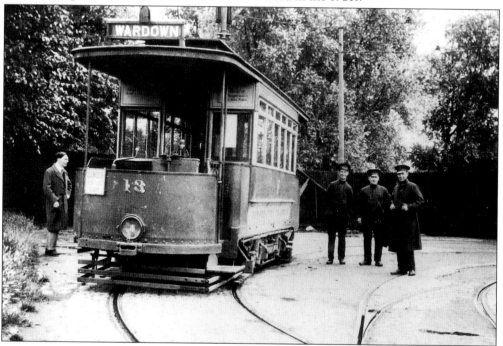

Tram number 13, *c*. 1927. This was bought from Glasgow Corporation in June 1923 and was a one man operated single-decker.

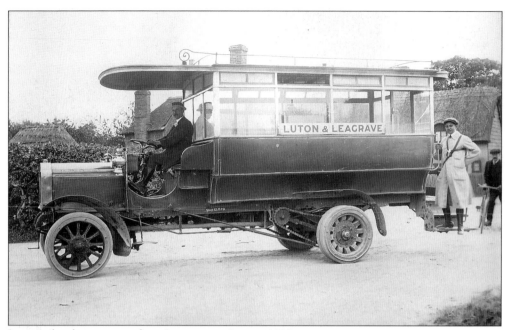
Luton's first bus running from Leagrave to Luton, 1909.

Upper George Street during the removal of the tramlines, 5 September 1932. (*Luton News*)

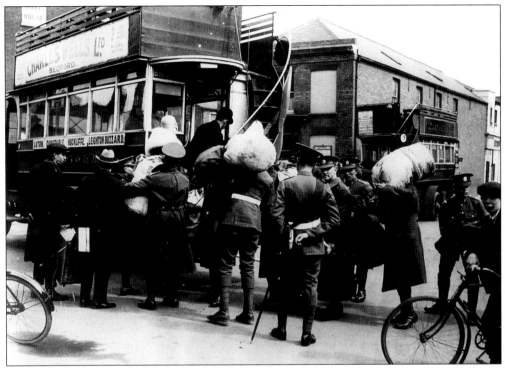

Double-decker buses with Territorial Army soldiers of the Bedfordshire and Hertfordshire Regiment boarding for special duty during the General Strike, 1926. (*Luton News*)

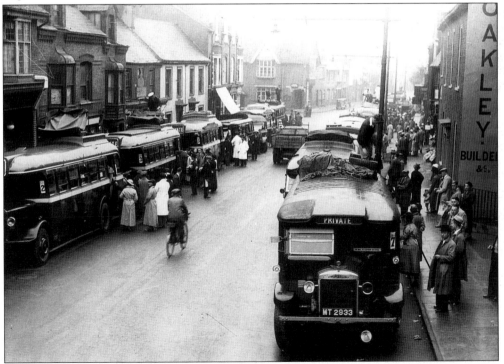

Private buses lined up in Park Street, collecting passengers, August 1936. (*Luton News*)

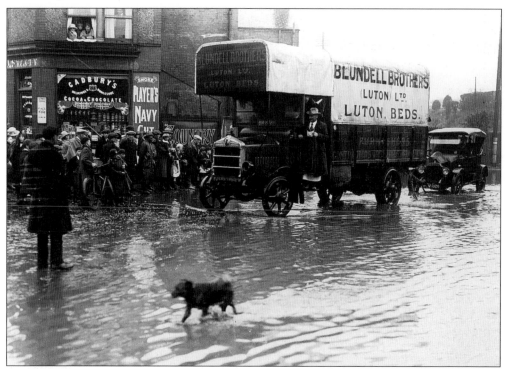

A Blundell Bros lorry towing a car through floodwater in the 1920s. Lorries and vans which had carrying capacity extended over the driver's head came to be known as 'Lutons'. (*Luton News*)

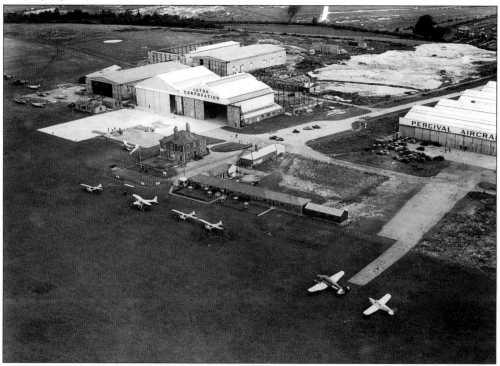

Aerial view of Luton Airport in the 1930s.

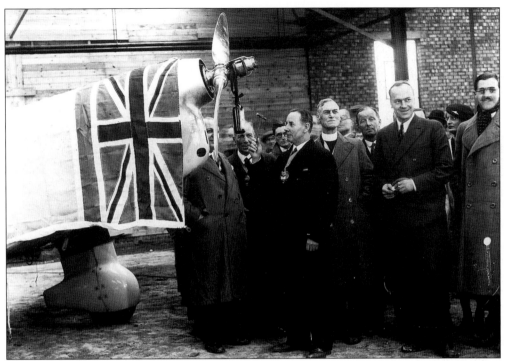

Percival Aircraft Ltd, the christening of a Percival Mew Gull, 1930s. The company came to Luton in 1936, before the opening of the airport, and set up on the site of Eaton Green Farm, adjacent to the developing aerodrome.

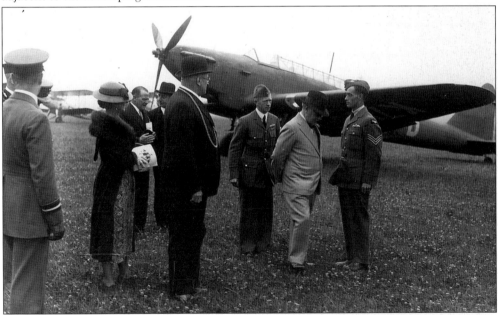

Luton Airport opening day, 16 July 1938. Left of centre, wearing his chain of office, is the mayor, John T. Harrison. Next to him, on the left, is Dr Leslie Burgin, MP for Luton, and on the right is Sir Kingsley Wood, Secretary of State for Air. They are inspecting the crew of a Fairey Battle bomber. (*Luton News*)

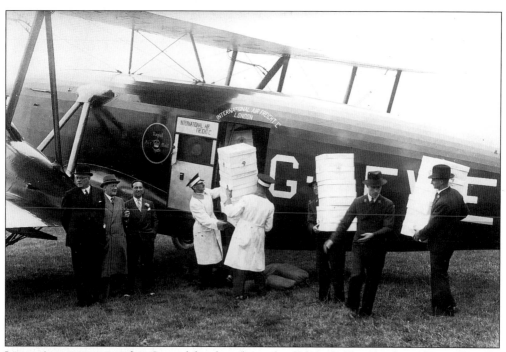

Luton Airport opening day. Special freight is being loaded, probably straw hats. (*Luton News*)

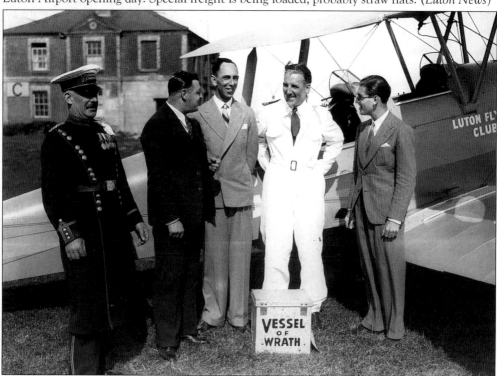

Luton Flying Club at the Airport on 30 July 1938. Captain E.W. Bonar of the club, having flown the film *Vessel of Wrath* from London for a special preview at Luton, hands it to the manager of the Union Cinema, A.E. Capper. (*Luton News*)

Six
Wartime

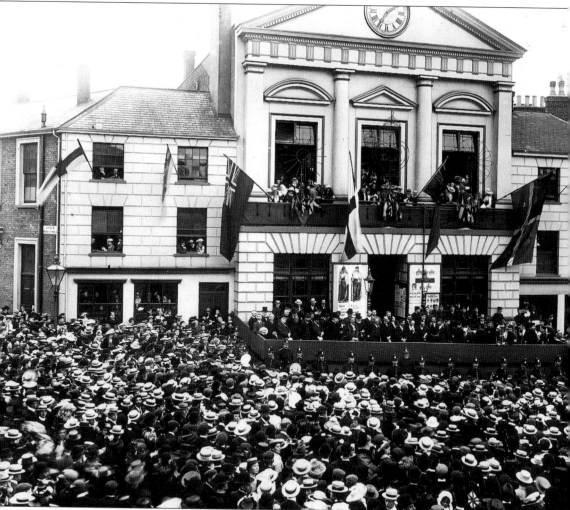

Boer War peace celebration at the Town Hall, 1902. The clock was installed to mark the end of an earlier war, the Crimean, and the inscription on it reads: *The Corporation of Luton, To Commemorate the Peace of 1856.* (F. Thurston)

A fund-raising occasion to support the war effort in front of the Town Hall, 1916. Just left of centre, with hand in pocket, is the mayor, John H. Staddon. Fourth to the right of him, with arms folded, is Henry Impey, mayor of Luton during the Peace Day riot of 1919. (F. Thurston)

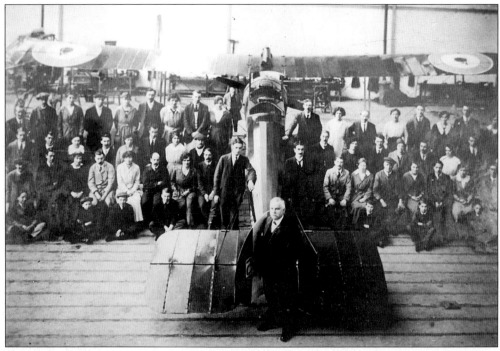

Hewlett and Blondeau's aeroplane factory, Oak Road, later Oakley Road. Aeroplanes were manufactured here during the First World War. After the war the site was taken over by Electrolux for its new factory.

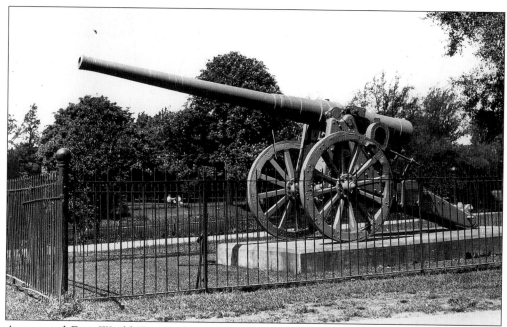

A captured First World War Turkish field gun presented to the town in recognition of the involvement of Luton men in the Gallipoli Campaign where many were killed. Between the wars it was displayed in Wardown Park but was melted down for scrap in March 1941. (*Luton News*)

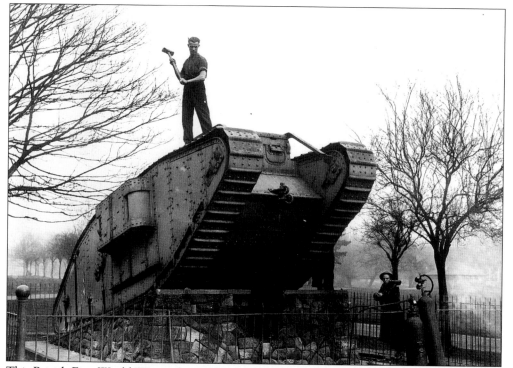

This British First World War tank was also displayed in Wardown Park and was scrapped at the same time as the field gun. (*Luton News*)

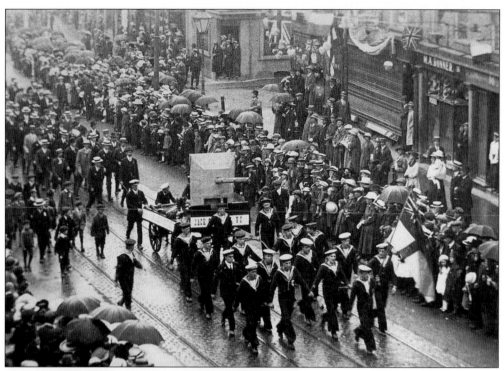

Naval ratings in the Peace Day procession of 19 July 1919 with the entry commemorating John Cornwell VC.

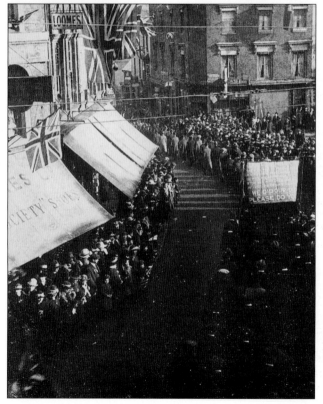

There was bad feeling among the town's ex-servicemen against the Council which had denied them permission to hold a service at Wardown Park. Their banner proclaiming, 'We did our duty please do yours' sums up their mood.

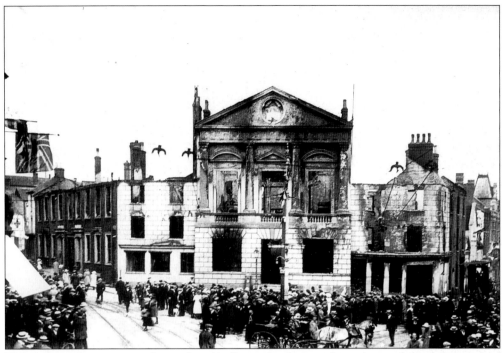

The anger and resentment directed at the Council culminated in a riot and the destruction of the Town Hall.

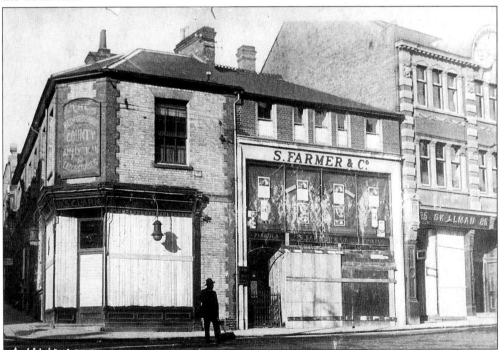

Farmer's music shop and neighbours boarded up after the Peace Day riot. The shop had been looted and pianos dragged out to accompany the singing of wartime songs while the Town Hall burned.

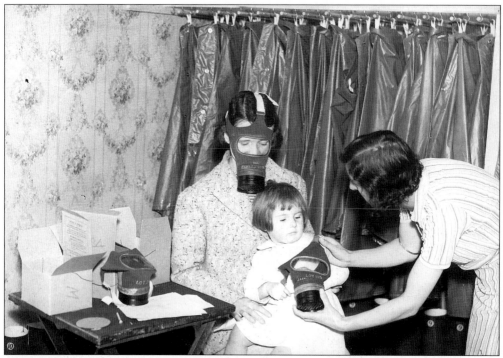

Gas masks for children and adults, September 1938. (*Beds and Herts Evening Telegraph*)

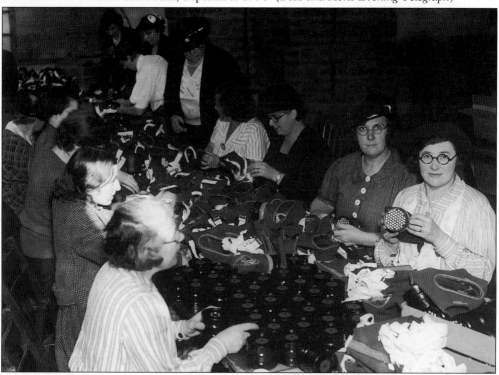

Assembling gas masks at the Peel Street depot under the supervision of Lady Keens, September 1938. (*Beds and Herts Evening Telegraph*)

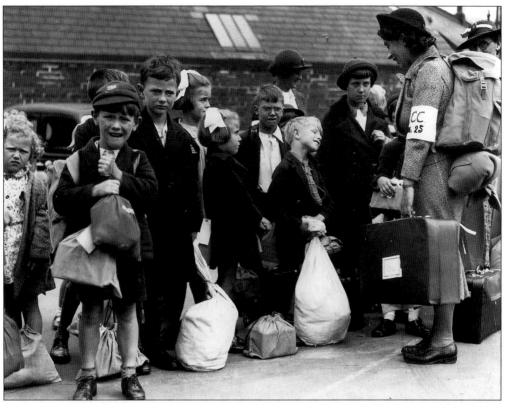

Evacuees arriving from London, May 1939. (*Luton News*)

Air raid drill practice at Denbigh Road School, 1939. (*Luton News*)

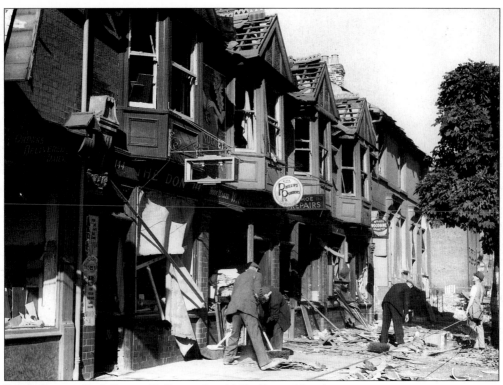

Bomb damage, Park Street, 22 September 1940. (*Luton News*)

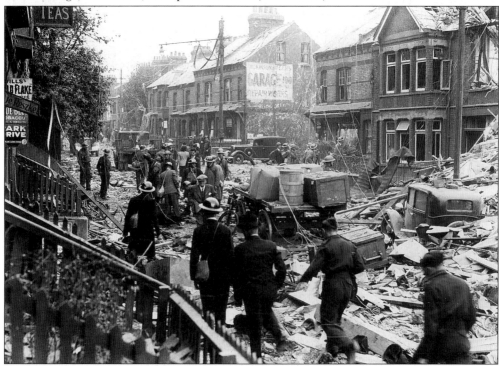

Bomb damage, Old Bedford Road, 15 October 1940. (*Luton News*)

Oil smoke canisters in Dallow Road, winter 1940/41, providing an oily smoke screen against air raids. (*Luton News*)

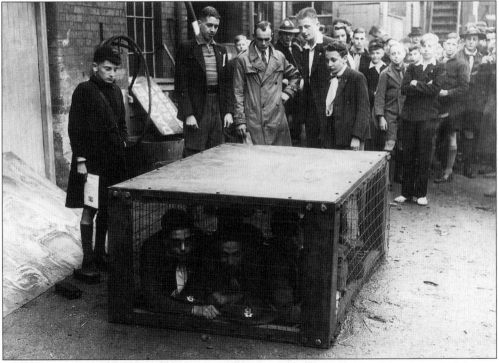

A 'Morrison' air raid shelter, named after Herbert Morrison the Home Secretary, for use in private houses. A demonstration by scouts in August 1941. (*Luton News*)

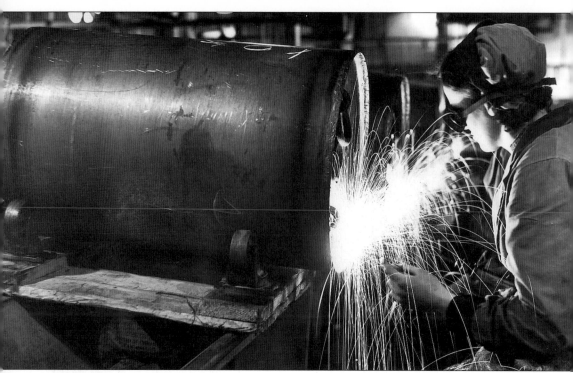

During the Second World War depth charges were made at Electrolux's factory. Here a woman welds one of the drums. (Electrolux UK Ltd)

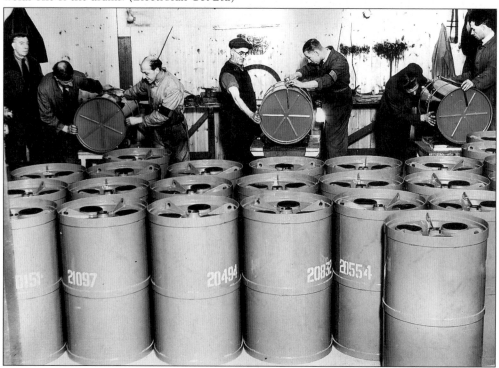

The completed depth charge drums being inspected. (Electrolux UK Ltd)

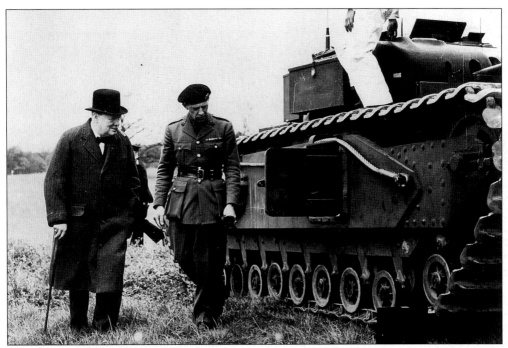

Winston Churchill inspecting a Churchill tank, June 1941. The tanks were made at the Vauxhall works from 1941 onwards. By the end of the war some 5,640 had been constructed either wholly at Luton or assembled elsewhere from parts made in the town. (*Luton News*)

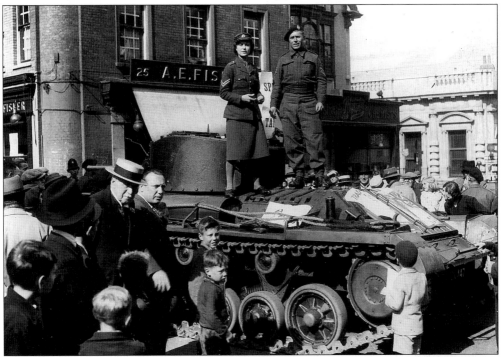

An Auxiliary Territorial Service (ATS) corporal and sergeant of the Royal Tank Regiment standing on a Valentine tank at the bottom of Market Hill, 12 August 1941. (*Luton News*)

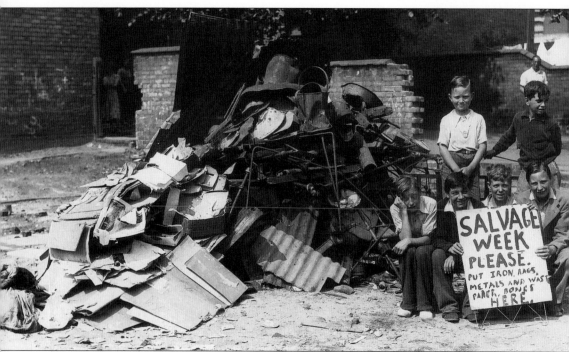

Salvage Week, February 1942. (*Luton News*)

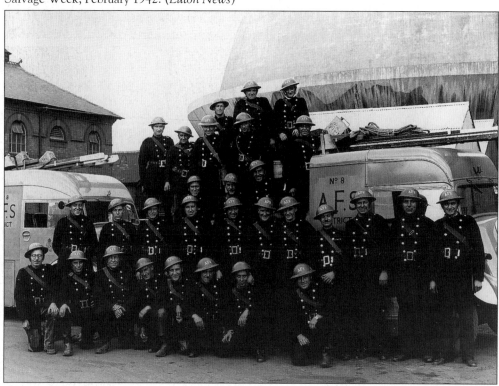

Auxiliary Fire Service (AFS) at the electricity works during the Second World War. (*Luton News*)

The Town Hall during Warship Week, 7-14 March 1942. Notice the sacking used to cover the white stone to make it less visible to enemy aircraft. (*Luton News*)

Marks and Spencer's shop in George Street during Warship Week. (*Luton News*)

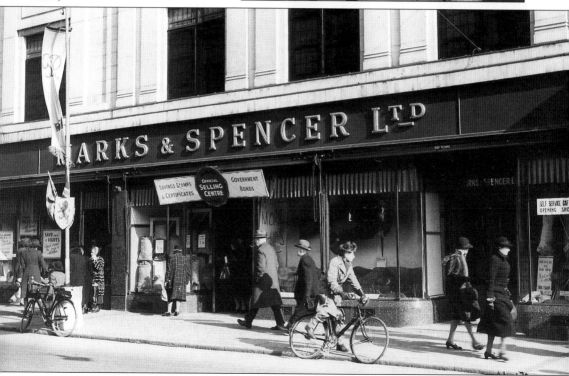

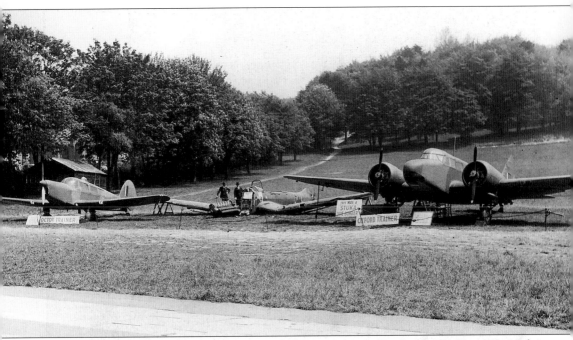

Aircraft displayed in Pope's Meadow during Wings for Victory Week, 15-22 May 1943. In the centre is a shot-down Stuka dive-bomber. (*Luton News*)

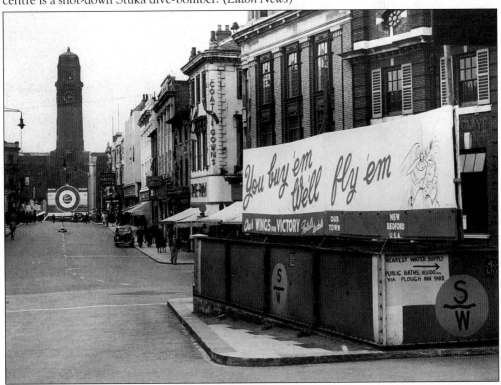

'You buy 'em we'll fly 'em' declares the fund-raising poster in George Street in Wings for Victory Week. (*Luton News*)

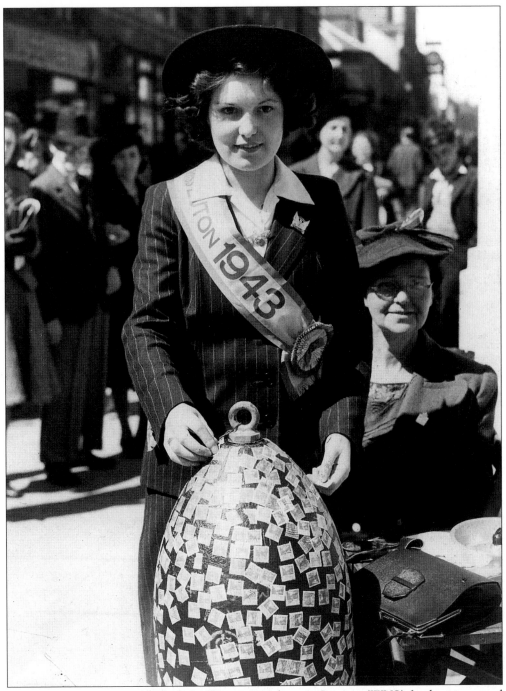

Dilys Evans, Miss Luton 1943, at the Women's Voluntary Services (WVS) fund-raising stand during Wings for Victory Week. A bomb casing is being covered with savings stamps. (*Luton News*)

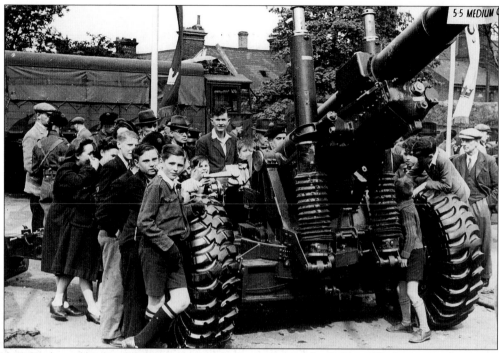

A 5.5inch medium artillery gun on display during Salute the Soldier Week, 29 April - 6 May 1944. (*Luton News*)

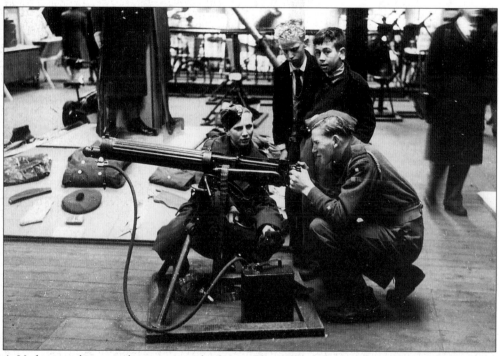

A Vickers medium machine gun on display in Blundell's department store during Salute the Soldier Week. (*Luton News*)

Seven
Recreation and Leisure

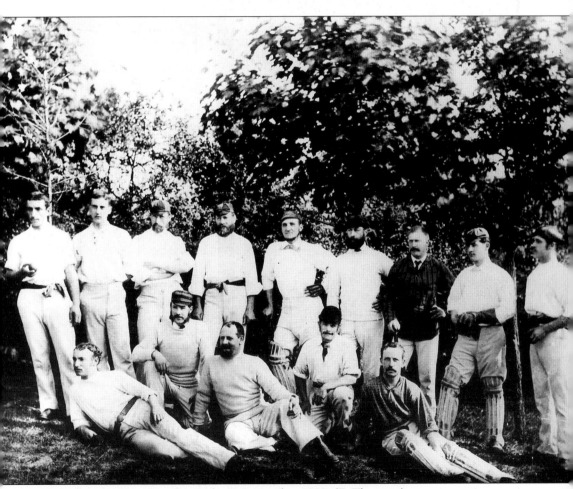

A group of cricketers at People's Park, 18 September 1883. (F. Thurston)

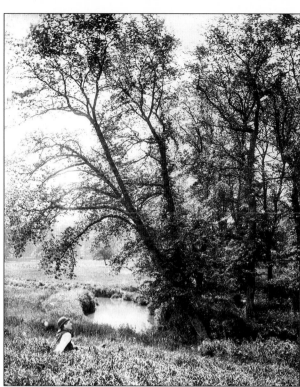

View across the River Lea as it enters Luton Hoo estate, 1885. (F. Thurston)

A paddle boat on Luton Hoo lake, July 1885. (F. Thurston)

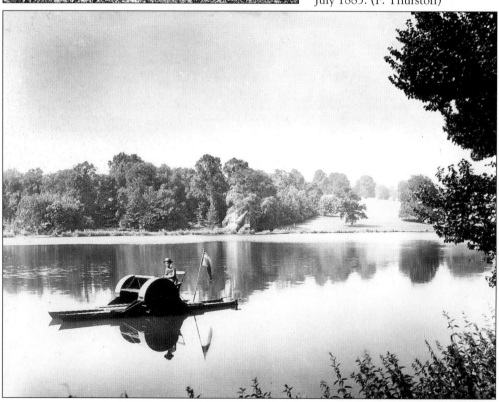

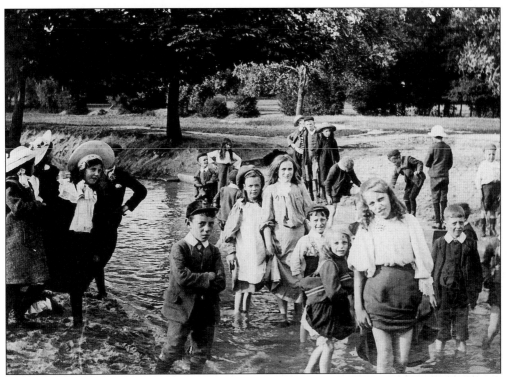

Children playing at Wardown Park, *c*.1914.

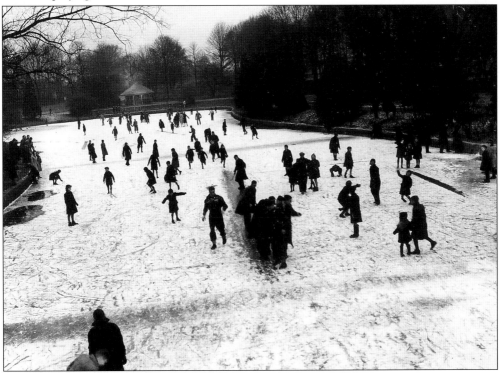

Playing on the ice on Wardown lake, January 1941. (*Luton News*)

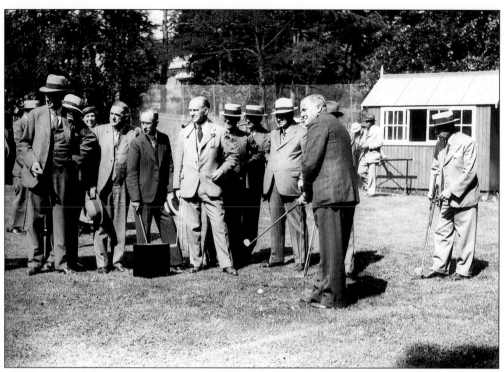

The opening of the miniature golf course at Wardown Park, 19 June 1934. (*Luton News*)

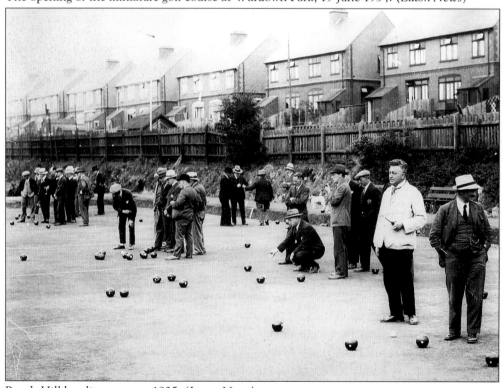

Beech Hill bowling green, *c.*1925. (*Luton News*)

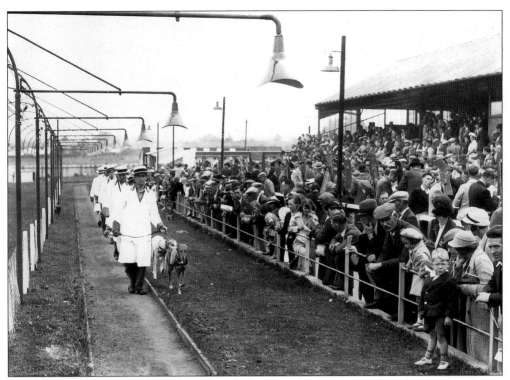

Parade of runners at Luton's greyhound stadium, Skimpot, August 1937.

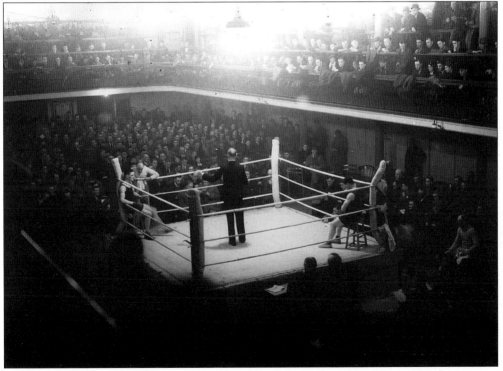

Boxing tournament at the Winter Assembly Hall, 27 December 1934. (*Luton News*)

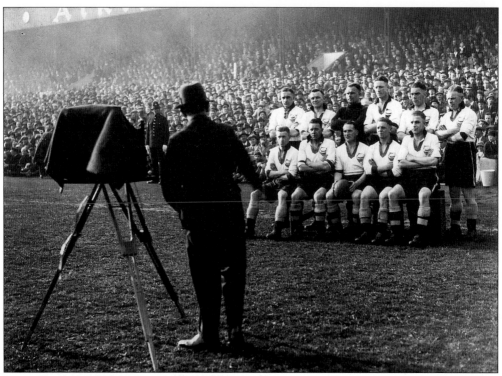

Luton Town Football Club, 1935/36. (*Luton News*)

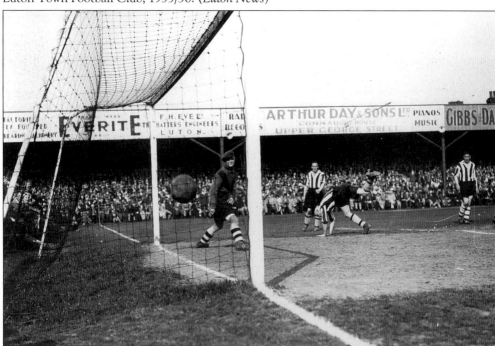

Luton Town Football Club v. Torquay United Football Club at Kenilworth Road, May 1937. Luton won 2-0 and gained promotion into the second division. The picture shows one of Joe Payne's two goals. (*Luton News*)

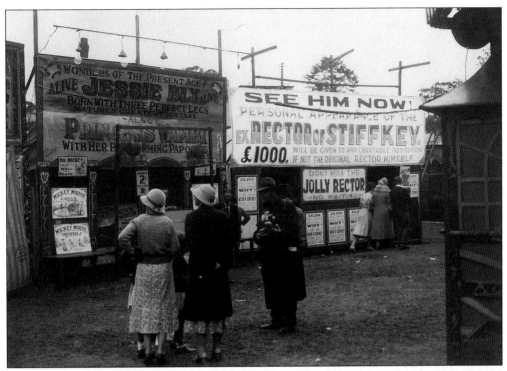

A fairground, probably at Wardown Park, 1937. (*Luton News*)

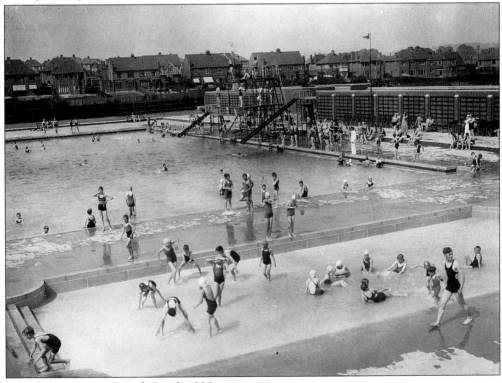

Luton's open-air pool, Bath Road, 1938.

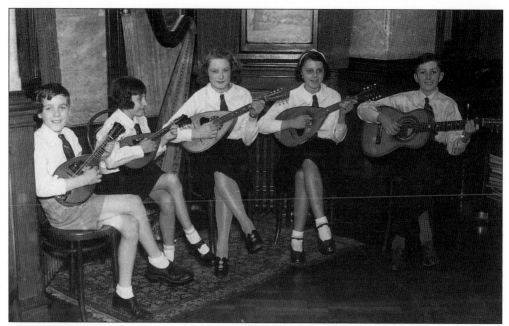

Luton pupils of Irene Bone competing in the annual contest of the British Federation of Mandolinists and Guitarists held in London in October 1938. (*Beds and Herts Evening Telegraph*)

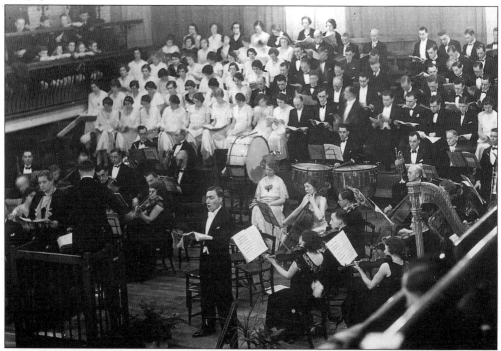

Luton Choral Society conducted by John Fry performing in the Winter Assembly Hall in the 1930s. The society was founded in 1866. Between 1940 and 1960 it was conducted by Arthur E. Davies, renowned for his work with Luton Girls' Choir. He introduced a series of concerts involving both choirs.

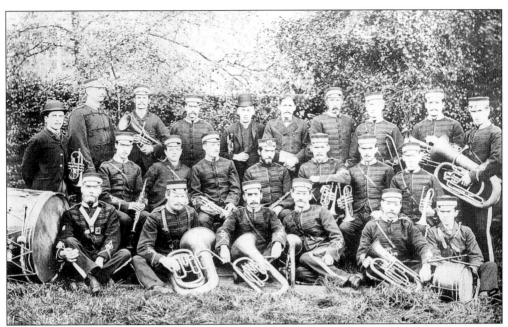

Ashton Street Mission Band, c.1885. The Red Cross Band was formed from this band when in August 1890 Harry Cannon, its conductor, left with some sixteen members to start a new band. This enabled them to enter contests with other bands which they had been unable to do as the Mission Band.

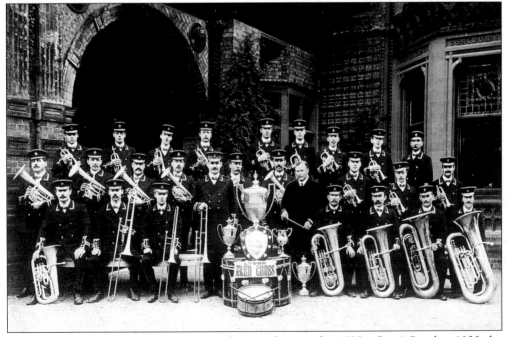

Luton Red Cross Band displaying some of its trophies in the 1920s. On 4 October 1923 the band won the prestigious Crystal Palace Championship, the first time it had been won by a band in the south. In 1930 it changed its name to the Luton Band when the name 'Red Cross' was reserved for relief work.

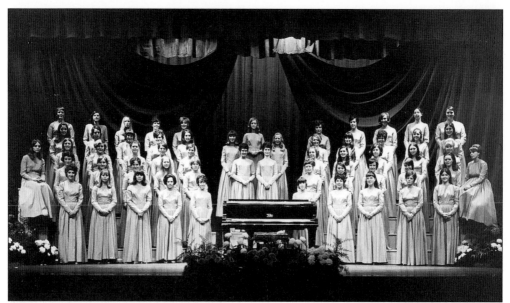

Luton Girls' Choir performing at St Albans in the early 1970s. The choir was formed in 1936 by Arthur E. Davies and grew out of the Sunday school choir at the Ceylon Baptist Church in Wellington Street. In thirty-nine years as a choir they made some fifty recordings and raised over £100,000 for charities. They travelled over 190,000 miles and made a number of overseas trips including a three month long tour of Australia and New Zealand in 1959.

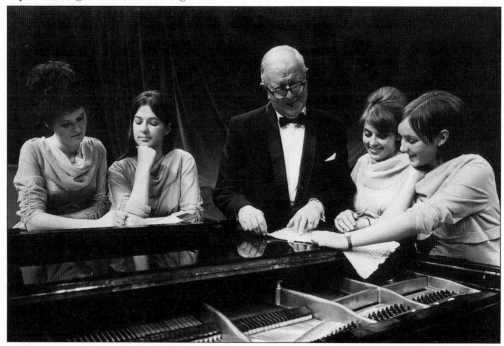

Arthur E. Davies and four choir members at the piano at St Albans in the late 1960s. Davies was the choir's only musical director. It disbanded in 1976 when Davies could no longer continue to conduct it. He died in May 1977 and the choir played one final concert at the parish church in November 1977 in tribute to him.

104

Eight
People and Events

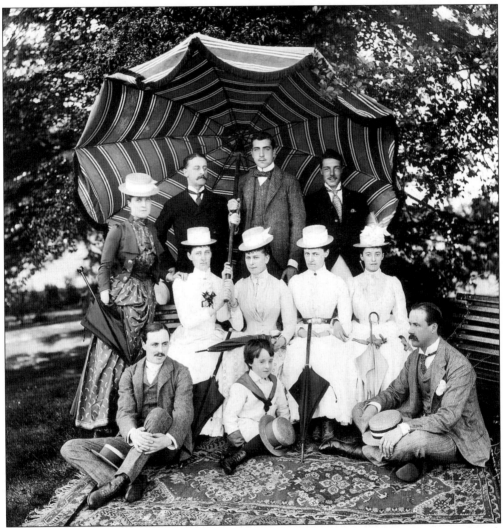

A house party at Luton Hoo on the occasion of the engagement of Princess May of Teck (centre) to Prince Albert Victor, 3 August 1888. On his sudden death in 1892 she married his brother, the future King George V and reigned with him as Queen Mary from 1910 until 1936. (F. Thurston)

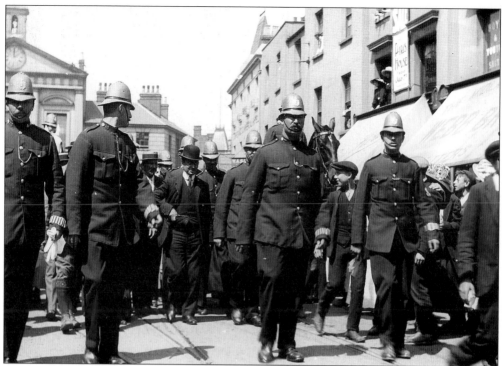

Luton Borough police force at the 1911 by-election with Cecil Harmsworth, the new Liberal MP. Note the officers' straw helmets.

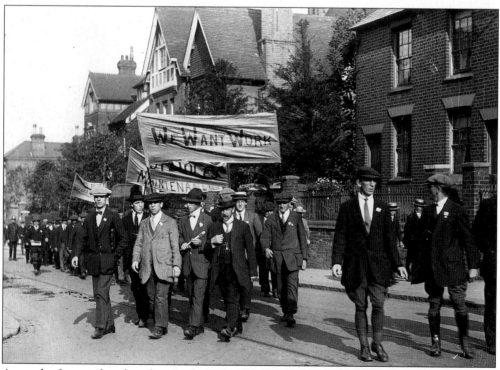

A march of unemployed workers in the Dunstable Road area in the 1920s. (*Luton News*)

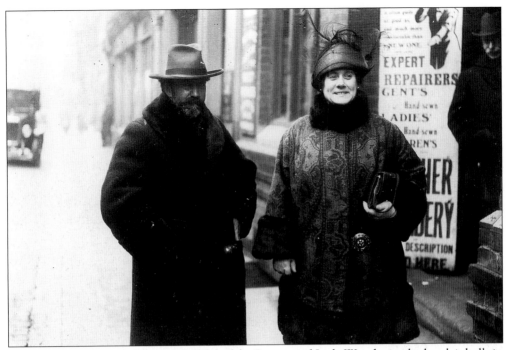

Sir Henry Wood, conductor and founder of the Proms, and Lady Wood outside the plait halls in the 1920s.

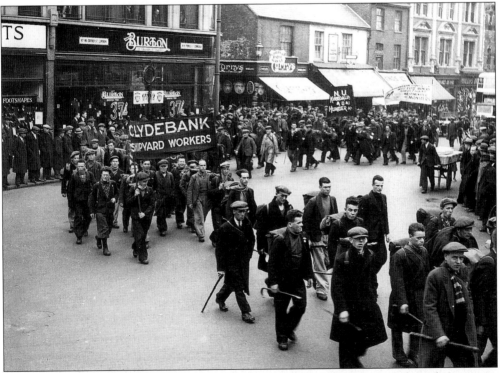

Scottish marchers protesting about unemployment in the 1930s, passing through Luton on their way to London.

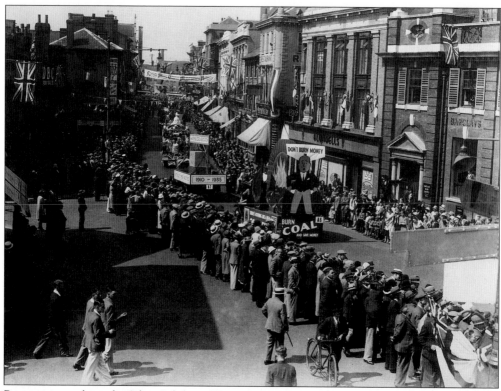

Procession marking the Silver Jubilee of King George V, May 1935. (*Luton News*)

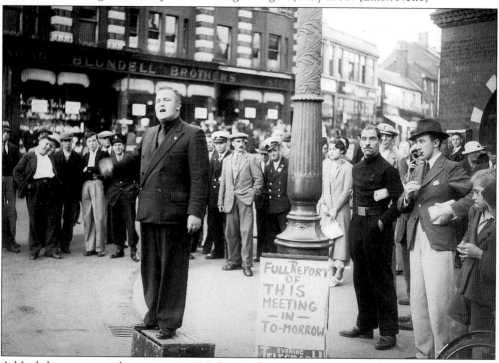

A blackshirt orator and supporters on Market Hill, May 1936. (*Luton News*)

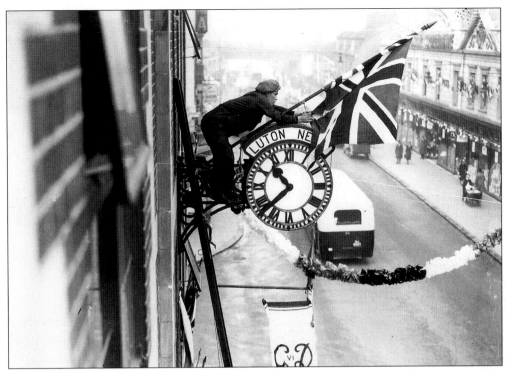

A brave soul fixing decorations on to the *Luton News* clock, Manchester Street, to mark the coronation of King George VI, May 1937. (*Luton News*)

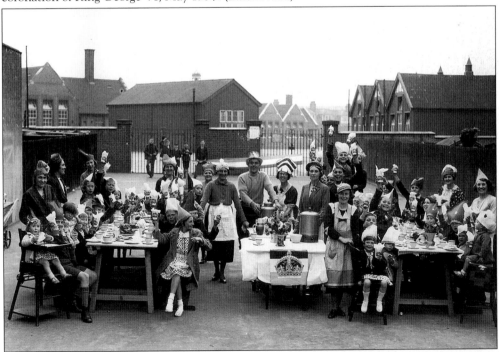

A street Party in Hampton Road to celebrate the coronation of King George VI. In the background is Beech Hill School. (*Beds and Herts Evening Telegraph*)

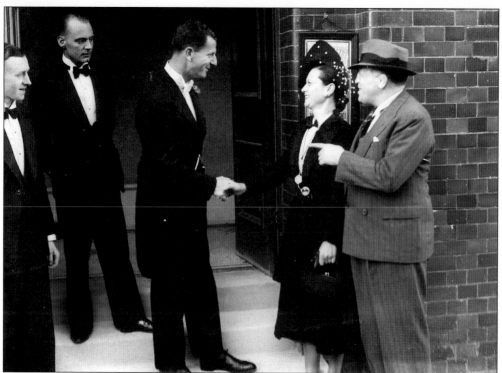

Ted 'Kid' Lewis, former champion boxer, and his wife greeted at the Grand Theatre by D.J. Newton, August 1938. (*Beds and Herts Evening Telegraph*)

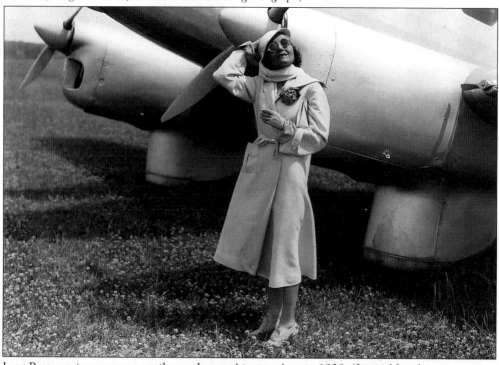

Jean Batten, pioneer woman pilot, at Luton Airport, August 1938. (*Luton News*)

George Bernard Shaw in the 1930s. He lived near Luton at Ayot St Lawrence and frequently visited the town to speak in support of the Labour Party. (*Luton News*)

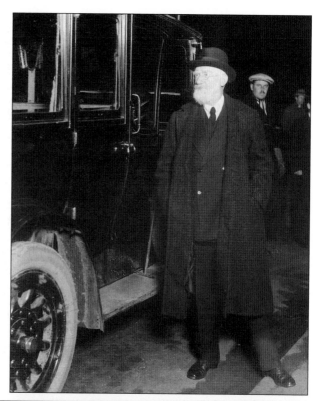

Valerie Hobson, later Lady Profumo, guest star at the opening night of the Odeon Cinema, 12 October 1938.

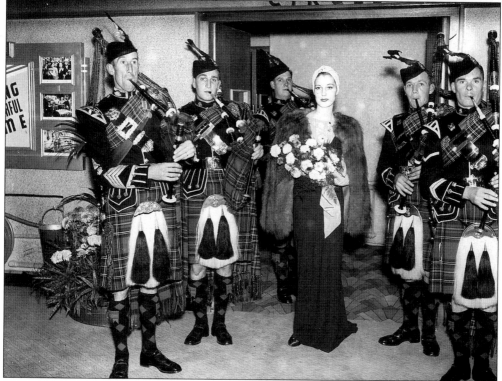

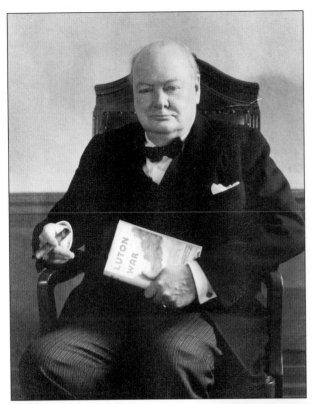

Sir Winston Churchill on his visit to Luton in June 1948, holding a copy of the *Luton News'* publication, *Luton at War*. (W.H. Cox)

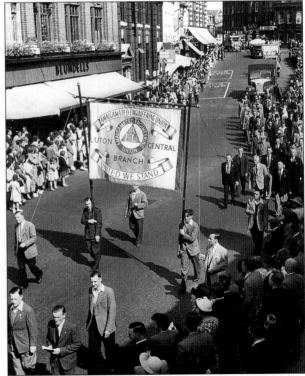

A procession to celebrate the centenary of the Amalgamated Engineering Union (AEU), passing into George Street, 16 June 1951. (AEEU)

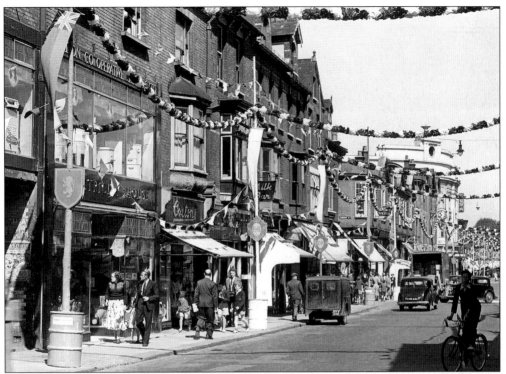

Manchester Street decorated for Queen Elizabeth's coronation on Tuesday 2 June 1953.

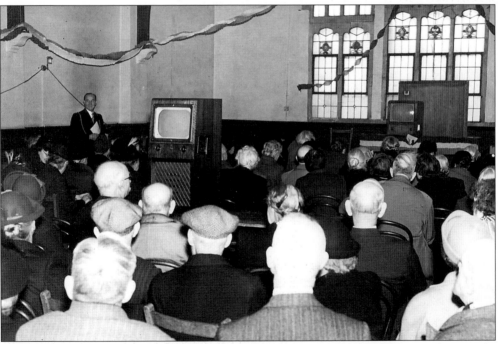

A large number of people watched the coronation on television, many viewing television for the first time. Here a group of pensioners have gathered to watch the service at Westminster Abbey.

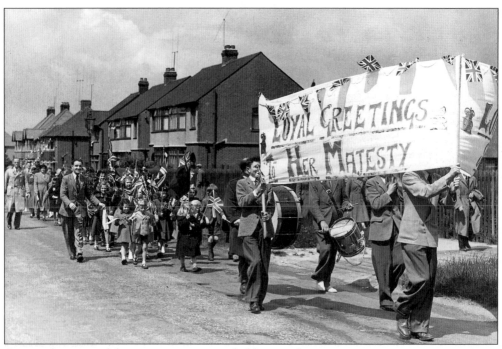

A scene from one of the many street parties held across the town.

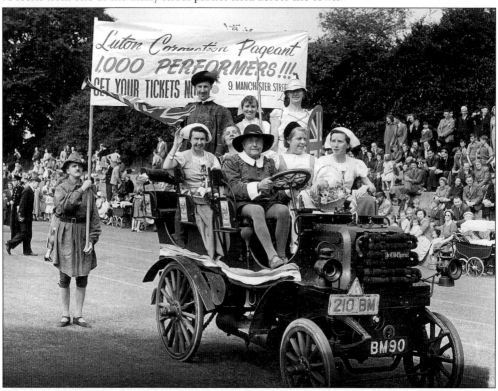

An entry in the coronation procession on Saturday 6 June advertising the pageant which took place at Luton Hoo the following week.

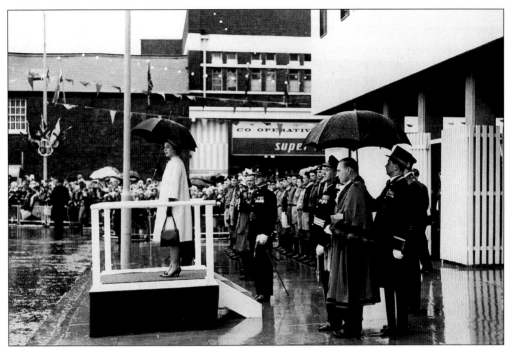

The Queen came to visit Luton Central Library on 2 November 1962. Here she is taking the royal salute from the 1st Battalion the Beds and Herts Regiment, Territorial Army. Sharing an umbrella behind and to the right of the Queen are the Lord Lieutenant and the mayor, Hugh M. Drummond. In the background is the Co-op store. (*Luton News*)

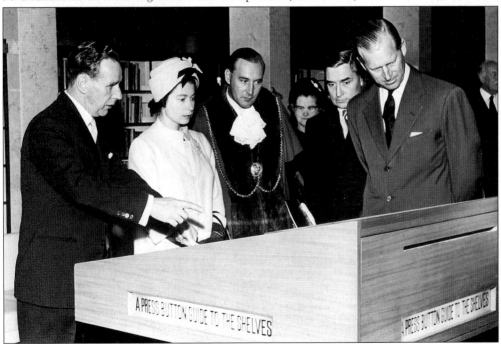

Frank Gardner, the Borough Librarian, explaining how to use the press button guide to the library shelves. (*Luton News*)

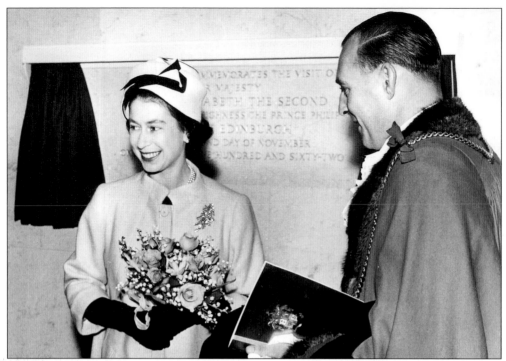

The Queen having just unveiled a plaque in the library entrance hall commemorating her visit. (*Luton News*)

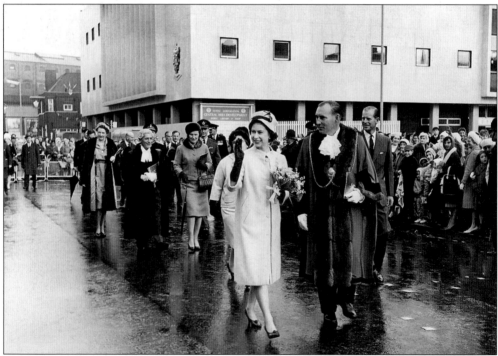

The Queen leaving the library, by which time the heavy rain, which had fallen all morning, had stopped. (*Luton News*)

Nine
Churches, Hospitals and Schools

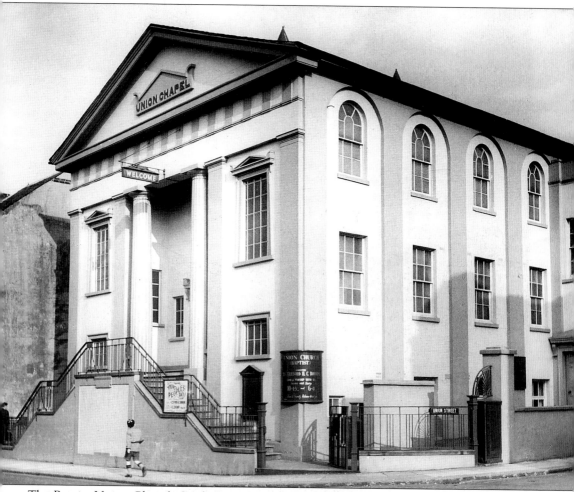

The Baptist Union Chapel, Castle Street, September 1959. It was built in 1836 and after the building was sold in 1986, converted into flats. The original set of steps leading down to the road had to be altered to the sideways arrangement shown here when the road was widened. (E.G. Meadows)

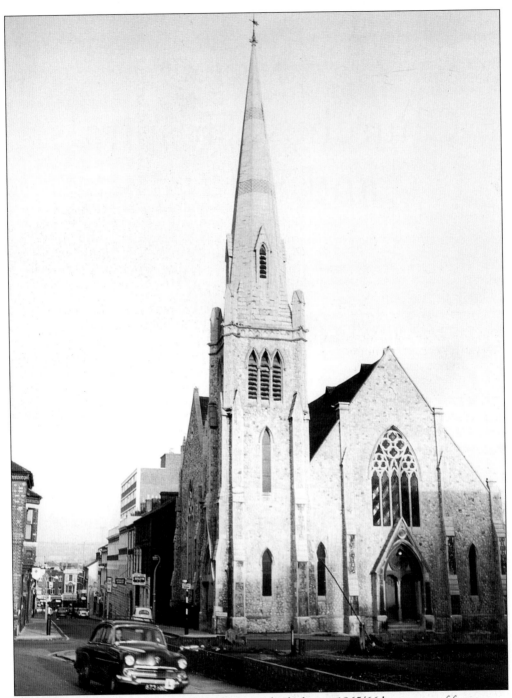

King Street Congregational Chapel, 1966. It was built during 1865/66 by a group of former Baptists who split from the Union Church. It was said to have the best orchestra in town. It was demolished in 1970 because it was structurally unsound. (E.G. Meadows)

Bailey Hill Weslyan Methodist Chapel, on the corner of Albert Road and Baker Street. It was built in 1898 and demolished in the 1960s.

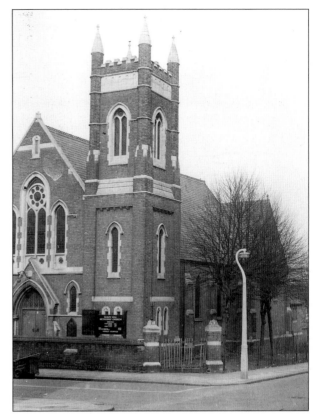

Waller Street Wesleyan Methodist Chapel, c.1900. It was built in 1863 on the corner of Waller Street and Cheapside. It was closed in 1954 and demolished in 1962.

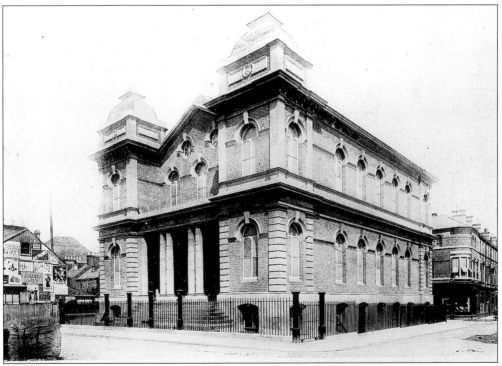

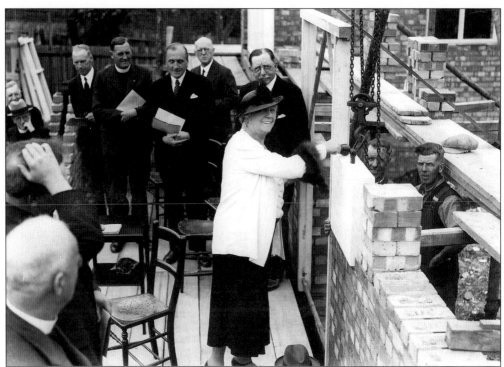

Lady Keens laying the foundation stone of the Blenheim Crescent Baptist Chapel, 10 July 1937. (*Luton News*)

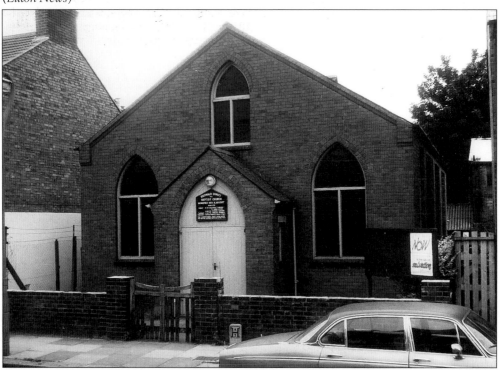

Reginald Street Baptist Chapel, *c*.1975.

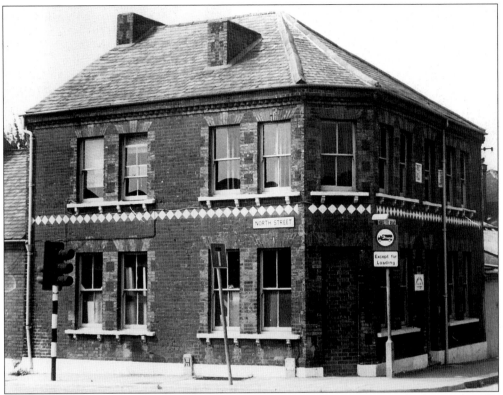

The house on the corner of North Street and Havelock Road, High Town, which served as the Children's Sick and Convalescent Home from 1889 to 1894. Here it is photographed in 1984.

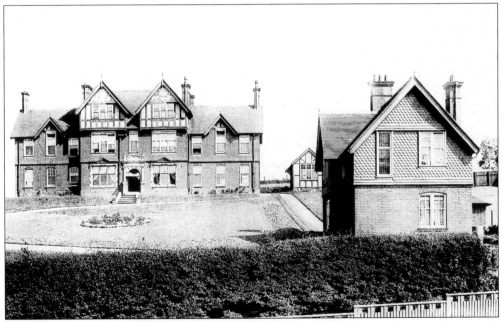

Children's Sick and Convalescent Home, London Road, c.1900. This new Home with room for expansion opened in 1894.

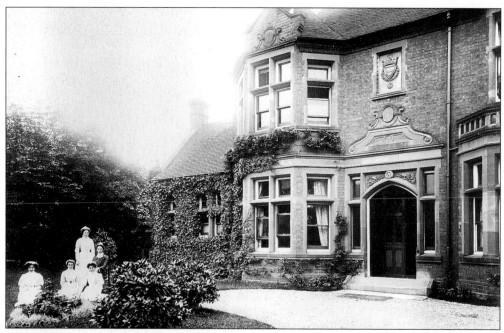

The Bute Hospital and staff, Dunstable Road, c.1900. Luton Cottage Hospital was established in 1872 in High Town Road. In 1882 it moved to this new building in Dunstable Road on land given by the Marquis of Bute and so became known as the Bute Hospital. It served the town until March 1939 when it was superseded by the Luton and Dunstable Hospital. Note the Bute coat of arms over the front door. (F. Thurston)

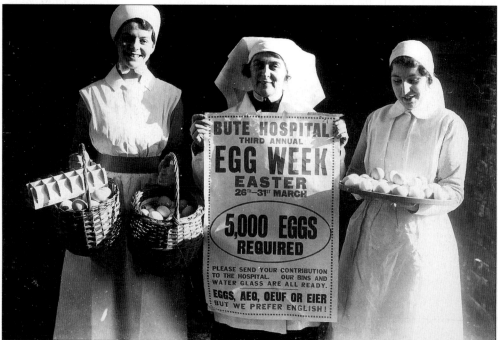

Miss M.E. Redman, matron of the Bute Hospital, and two nurses collecting eggs in Egg Week, Easter 1934. The first Egg Week was in 1932 when 3,176 eggs were given. (*Luton News*)

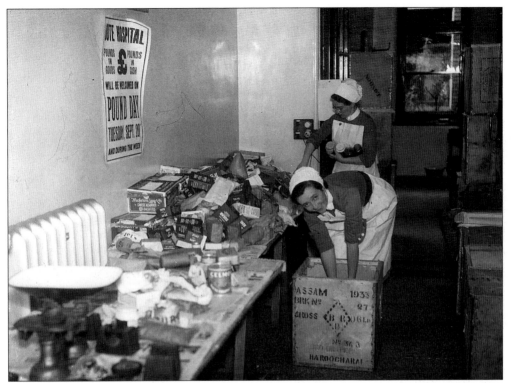

Bute Hospital Pound Day, 20 September 1938. In this annual event, inaugurated in 1906 by the matron, Miss Poulton, the public were encouraged to donate gifts such as groceries weighing one pound. (*Beds and Herts Evening Telegraph*)

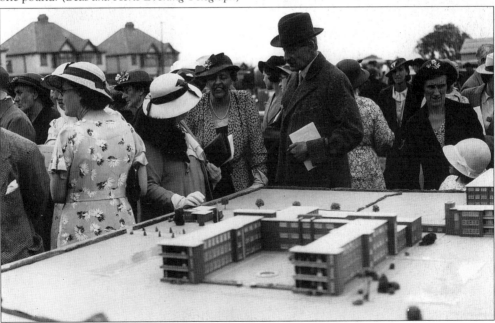

Model of the Luton and Dunstable Hospital on view after the foundation stone laying ceremony, 28 June 1937. (*Luton News*)

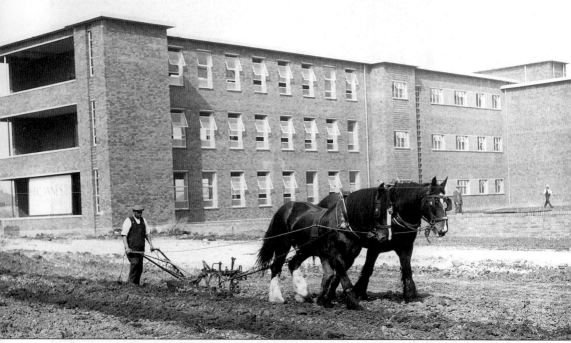

Horse and plough in front of the Luton and Dunstable Hospital in September 1938, five months before it opened. (*Luton News*)

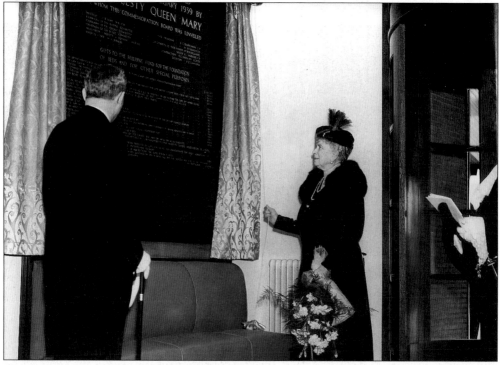

Queen Mary opening the Luton and Dunstable Hospital on 14 February 1939. With her is the hospital's president Dr J.W. Bone. (*Luton News*)

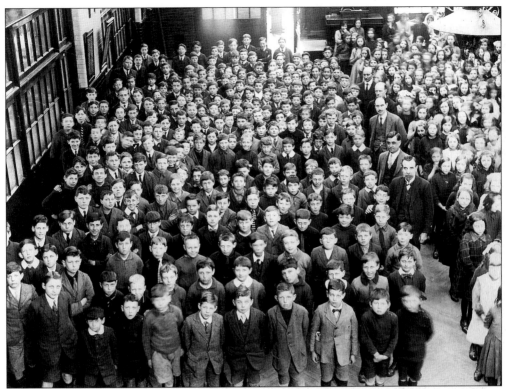

Group photograph at Dunstable Road School on the retirement of J. Needham in 1922.

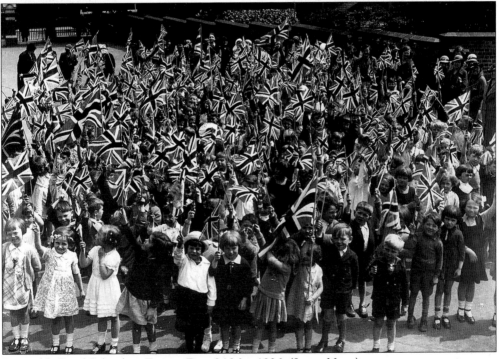

Dunstable Road School on Empire Day, 24 May 1936. (*Luton News*)

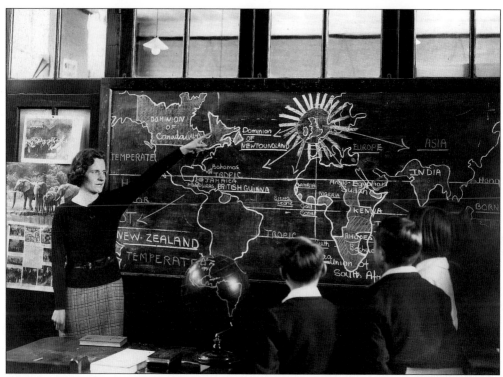

Dunstable Road School class on Empire Day, 24 May 1936. (*Luton News*)

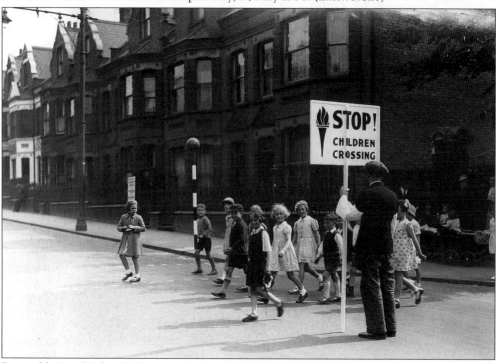

Dunstable Road School. The school's first 'lollipop man' seeing pupils across Dunstable Road, 1938.

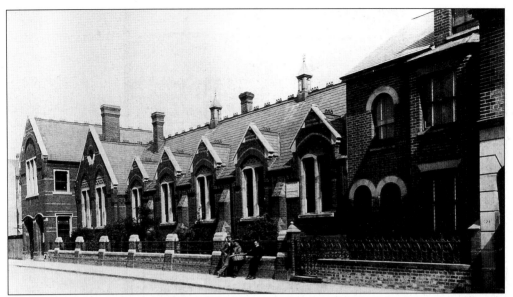

Waller Street School. It was built in 1876 following the creation of a School Board in 1874. In 1890 it became a Higher Grade School marking the beginning of secondary education in the town. Boys could join it from other schools if they reached the required standard. It closed in 1939 and was demolished in 1969.

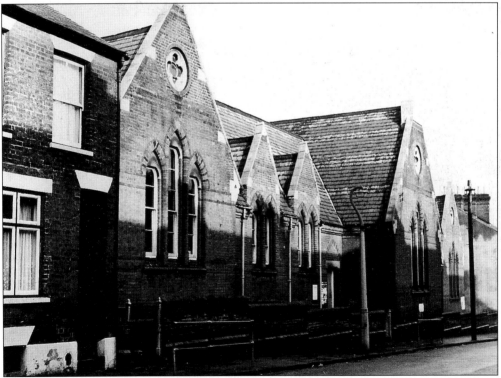

Christ Church School, Buxton Road, c.1960. A National (i.e. Church of England) School built in 1874, it closed in 1965, when there were fewer children living in the town centre, and was demolished in 1968.

Queen Square School, 1930. Originally a National School built in 1857 for 384 boys, it closed in 1965 and was demolished in 1973.

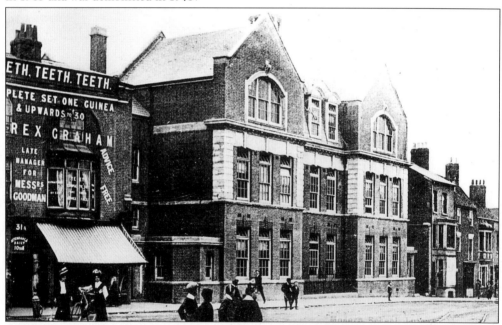

Luton Modern School, Park Square, *c.* 1910. Opened in 1908, it became Luton Technical College in 1938 when the Modern School moved to Bradgers Hill Road. The Technical College subsequently moved to a new site on New Bedford Road, later re-named Barnfield College. The old Technical College was demolished in 1957 and was replaced by Luton College of Technology. This merged with Putteridge Bury in 1976 to form Luton College of Higher Education which became the University of Luton in 1993.